MAKING ART PAY

BERNARD DENVIR & HOWARD GRAY

PHAIDON · OXFORD

Phaidon Press Limited, Musterlin House,
Jordan Hill Road, Oxford, OX2 8DP

First published 1989
© Phaidon Press Limited 1989

A CIP catalogue record for this book is
available from the British Library

ISBN 0 7148 2519 0

Drawings by Julian Bingley

Printed in Great Britain at Alden Press
Limited, Oxford

Every effort has been made to ensure the
accuracy of this text at the time of going
to press. The Publishers would be
grateful for notification of errors or
omissions.

CONTENTS

INTRODUCTION

Although the romantic image of an artist is of a penniless bohemian starving in a cold attic, the reality is that because art is in greater demand by more people than ever before, artists can earn comfortable – even substantial – incomes from the practice of art. People such as David Hockney, Francis Bacon, and leading Academicians, especially those specializing in portraiture, earn incomes of up to six figures, and are sometimes forced to become tax exiles.

Luminaries such as these are, of course, the exception; although – assuming you have the talent – it is possible to make money out of art if you are prepared to be professional in your approach, and apply yourself single-mindedly to the task at hand.

This book is intended as a practical guide for all those who think they have what it takes to be a successful artist, whether they be experienced 'amateur' painters or sculptors, or art college leavers who are uncertain of how they can make a living from their skills.

Making the most of your talent often involves other disciplines and techniques that you're probably not even aware of, and this is where *Making Art Pay* can help, although at the end of the day it will, of course, only be able to advise you on what or what not to do – the rest is up to you.

What types of artist – or potential artist – will benefit from this book? First of all, there are the young (and their parents) who are thinking of becoming artists, and who want to know if it is a profession, calling or vocation which offers them a viable economic future. Then there are those who have just left art school, and who want to establish themselves as money-earning painters, sculptors, printmakers, etc.; as well as those of a slightly older age, who have already discovered the difficulties inherent in such a choice, and who want to improve their standing and incomes.

Finally, there is a much larger class of people who might be lumped together under the title of 'dual career' artists, who have skills in art, or are anxious to acquire them; who have a passion for expressing themselves in visual forms; and who, though not dependent on this activity, are anxious to increase the income which they receive from other sources. This may vary greatly, from a teacher's salary or an old age pension to a director's fees or a successful author's royalties.

There is also, one supposes, a very small minority (the Duke of Edinburgh and the Prince of Wales are two examples which spring to mind) who paint purely for pleasure and have no concern at all with economic reward. It is a small group. Even the rich and successful who are closet artists like to sell their paintings rather than give them away, and this is not

9

merely greed. Making art pay means that you are producing art which somebody likes enough to buy. It is an incentive to further effort, a spur to improvement.

Money is the essential link which binds art to the society in which it exists. Even idealists such as Van Gogh, or affluent men like Cézanne, were far more concerned with exhibiting and selling their works than we sometimes realize. An artist who never tries to exhibit or sell his work can all too easily become stuck in an ivory tower and lose his sense of direction.

The dual-career category contains a considerable number of variations. There are those whose full-time employment can be related to art itself – teachers of the subject in schools and elsewhere are the most obvious example – as well as those whose principal careers are totally unrelated to art.

Finally, there is a large and significant category who see their main activity as that of being professional artists, but who, not being able to make enough money out of it to satisfy their personal commitments, take on some other job in a part-time capacity, or even depend on the earnings of their spouse.

Addressing the question of how much you can earn from art – and it is impossible to put a general figure to it – involves taking into consideration your degree of commitment, how ambitious you are, how hard you work, what contacts you have, and a host of other factors over which you have little or no control.

The most obvious of these is the state of the economy. It is clear that in hard times people are going to buy less art. Then

there is the actual environment in which an artist finds himself. Outside London it is likely that more paintings are sold in art galleries in Bath than in Bradford; although where you live is often less important than locating the right market for your work.

Then there is the imponderable but important question of changing tastes. Even leaving on one side the fact that, by and large, realistic figurative art tends to sell more easily than avant-garde, what is popular in one decade can all too easily be unpopular in the next. To this last problem there is no real solution. Some artists are capable of changing their style to suit the fashion of the times, but many more can't, or won't. There are indeed those who have two styles: one for popular consumption, another for private pleasure.

Kurt Schwitters was one of the outstanding examples of this type, his main activity being the construction of those miscellaneous objects which now fetch great prices, while at the same time producing straightforward academic portraits which are now virtually worthless.

There is always the risk of appearing insincere if you change your style to fit the times, and there is always the slight consolation that if you live long enough and paint enough pictures, your style is likely to come back into fashion again anyway. Today, for instance, figurative painting is popular, and those who kept at it during the last two decades are now doing well. Apart from the big names, abstractions are unpopular – but they will undoubtedly enjoy a revival at some point in the future.

In terms of taking up a salaried job to

combine with your activities as an artist, probably the best choice is teaching art – although demand for art teachers has shrunk in recent years. Obviously, being an artist does not combine well with all jobs, and on the whole artists tend to choose occupations that allow them the time to pursue their creative activities.

Artists do, however, have a problem which is not shared by, say, writers or poets. Whatever their income, they probably have to spend far more on their materials and other expenses, such as the cost of transport, mounting an exhibition, etc. This, of course, can be partly off-set against income tax, but it can still account for up to 40 per cent of the income earned from sales and commissions.

This, then, is the general economic position which faces those who wish to pursue a career as artists. For most it will be a struggle financially, as expected earnings are likely to be a good deal less than in occupations of a similar social and technical standing. Indeed, it has been estimated that more than a quarter of all male single-career artists are registered as unemployed; so if you intend to make art your sole source of income, you would be advised to look closely at all the various opportunities before taking the plunge.

Outlets for Sales

What, then, are the best outlets for an artist? The simple answer is all of them – personal sales, commercial galleries, mixed exhibitions, self-organized exhibitions, commissions, projects, residencies, and various others that will be explained later.

Obviously, direct sales by commission or direct negotiation made from the home or studio are, as individual transactions, the most profitable, as there are no additional costs such as transport, insurance, etc. However, they are not as likely to generate further sales, unlike those which emerge as the result of a public exhibition.

One of the best outlets for obtaining an exhibition of one's paintings (though this does not necessarily mean selling them) is the Regional Arts Associations, of which there are twelve in England and three in Wales, offering support to individual artists for various projects, including financial assistance towards preparing work for exhibition. There is, however, always a high degree of selection for them.

Other good outlets are regional commercial art galleries, national mixed exhibitions and public institutions such as schools and libraries. London commercial art galleries are the least likely of all outlets to accept work by the average contemporary artist – a recent survey showed that only 12.5 per cent of all artists who applied to exhibit their works at this kind of commercial gallery were successful. It is, inevitably, the London commercial galleries which are most successful with sales, the major ones having a turnover of some £5 million a year, although much of this is from the sale of works by 'prestige' artists.

Many provincial galleries, on the other hand, have a higher proportion of works sold to works exhibited than their metropolitan counterparts, though at lower prices. What is really remarkable about professional British artists (unfortunately

there are no available figures for comparison with other nationals) is that no less than 40 per cent have never tried to exhibit outside their own locality, and 22 per cent who have done so have made no attempt to exhibit locally – all of which suggests a remarkable inertia.

How much you should charge for your works of art is difficult to judge, and depends on all sorts of factors peculiar to the art world. If you have a dealer who handles your works regularly, there is no real problem. He will have a fairly shrewd idea of what he will be able to get for them, and on the whole you should trust his judgement. If you do not have a dealer, you can always visit galleries to get an idea of the prices of works similar to your own.

It is worth not setting your sights too high at first, as this might very well frighten a prospective buyer. Many buyers are not aware of what prices are actually like in the contemporary art market, and the chances are they like to think they're getting a bargain. The time-honoured ploy to somebody who complains about the price being too high is to retort, 'But of course, that includes the frame.'

Believing in Yourself

Of course, whatever is said in a book can do little to help an artist project himself to the outer world, whether that world consists of dealers, customers or public authorities. In dealing with people who may buy your works, or publicize them, it is essential to strike the right balance between self-confidence and hubris. As with most things, you have to sell yourself to some extent, and enter into the spirit of the transaction.

One of the first lessons to be learned is that a rejection is not the end of the world. If a gallery refuses to accept your work, if it is rejected from an exhibition, or if you do not get a grant you applied for, do not lose heart; for none of these disappointments diminishes the intrinsic quality of your work, or alters your real standing as an artist.

The selection committees of big exhibitions have to look at thousands of paintings, and as with all forms of competition, decisions can often be arbitrary and influenced by factors other than mere aesthetic judgment. Also, although it is possible to distinguish between very good art and very bad art, there is a wide middle spectrum to which a great many artists belong, and here choices are more often than not a question of taste.

The really fatal attitude to take about any lack of success is to say the whole thing's a conspiracy. The most important quality a hopeful artist can possess is pertinacity, which means exploring every opportunity, leaving no avenue unexplored, no stone unturned. And linked to this there should be an incessant curiosity and alertness. Read as many papers and art magazines as you can; pick up ideas, look for vacancies, see what other people are doing. Also, consider other towns and cities as potential outlets for your work, and even countries other than Britain. And don't forget to keep your eye open for any publicity and keep a record of all your contacts.

In dealing with any customers, or clients, or patrons – whatever you prefer to call them – just be yourself and maintain an air of modest self-confidence. Explain as much about the work of art as you can, such as what you have been trying to do with the lines, the colour, the composition and so on. It doesn't really matter if the person with you knows what you're talking about or not. Any sort of art is an act of faith, and you must do all you can to foster belief.

LEARNING HOW TO DO IT

Although attending art school is not a prerequisite for being a successful artist, the skills that are taught there are without doubt of enormous benefit.

There are many categories of people who want to receive an education in art. There are school-leavers who have shown promise in the subject and wish to pursue it; there are more mature people who have discovered in themselves an ability to paint, draw or sculpt, but want a professional training to allow them to realize their full potential; there are those who have already received an art education and are anxious to learn more; and there are those who have retired, won the pools or managed to escape from the treadmill of working life, and want to fulfil what might have been a lifelong ambition to become an artist.

Art Colleges and Polytechnics

There is a diversity of institutions at which to study art. The various colleges and the courses they offer are outlined below.

The first step on the art education ladder is the Foundation course, which usually lasts for a year, or in some cases two. During the third term some of your time will be occupied in going for interviews and other activities to do with securing a place on a degree course.

Based on an idea from the famous German art school, the Bauhaus, the Foundation course has a dual purpose: the first is diagnostic, to give the student some idea of the disciplines open to him or her at art school; and the second is to teach some basic skills, especially in those areas such as design.

To gain admission to a Foundation course, you must apply to the college of your choice. If you want to obtain a 'discretionary' award from your local authority (that is, an award which they may or may not give, distinguished from 'mandatory' awards which, given the right conditions, the authority is bound by law to make) write to the authority concerned, and they will send you the application forms. There is always considerable competition for entry, so make sure you apply in good time (the deadline is usually January of the year you wish to start).

Entry requirements vary, but the general pattern is that for a two-year course you have to be at least sixteen years old and have certain GCSEs or O levels, which vary according to the institution. For a one-year course the minimum age is seventeen, and usually five GCSEs and one 'A' level are required. You will have to attend an interview, and the college will tell you about the formalities of applying for a grant, which differ from one local authority to another.

The next step is to apply to a university, college or polytechnic of your choice to be accepted on a degree course. It is impossi-

ble to give specific advice on which college to choose, apart from noting that those in the London area are most popular, not necessarily because of the excellence of their teaching, but because in the art world, as in other areas, the capital is seen – not unreasonably perhaps – as the place to get on in.

There are many variables in the corporate personalities of every fine art faculty. Some are avowedly avant-garde, some are traditionalist; some emphasize a disciplined approach, some advocate inspirational freedom; some rely on the traditions of a glorious past, some are building up a glorious future.

There are those colleges which are extremely good for subsidiary subjects such as printmaking or illustration, and those which are aggressively 'painterly'. Some are situated in beautiful semi-rural areas, others in the most squalid inner city environments. In an age of aggressive educational marketing, most art schools, art faculties (usually old art schools which have been absorbed into a polytechnic) and similar institutions have open days for aspirants, and some even organize excursions for sixth-formers from other areas. Another way of assessing these institutions is to find out when (usually in May or June) they have their annual exhibitions of works by students who are graduating in that particular year.

Entry Requirements

Polytechnic and art college degrees in fine art and allied subjects are awarded by the Council for National Academic Awards, which nominates external assessors to supervise the standard of work. Its entry requirements operate over the whole spectrum of the first-degree courses it supervises.

These entry requirements are normally a minimum age of eighteen on the last day of the year in which the course starts, and successful completion of a Foundation course. The minimum academic qualifications are usually two A levels plus GCSEs (or O levels).

Sometimes equivalent qualifications are acceptable. Although these requirements usually apply to people between the ages of eighteen and twenty-five, a slightly more tolerant attitude is adopted to mature students, especially if they can show some proof of achievement in the field of their choice, for example, if they have had an exhibition or had works accepted by a prestigious organization.

The final date for applications for admission to a degree course is 31 March. Application forms, when they are not available at the educational establishment to which you belong, can be obtained from: **The Art & Design Admissions Registry**, 24 Widemarsh Street, Hereford HR4 9EP.

There is a registration fee, and you have a first or second choice. If you succeed in neither, you revert to the 'pool', which consists of those colleges which have not been able to fill all their existing vacancies. If you are doing a Foundation course, the forms will be returned by the institution; otherwise, return them yourself.

First choice interviews take place in mid-April, second choice at the end of

May, and continue during the summer for the pool. The tutors on your Foundation course will give you advice about the best works to take for an interview, though there is nothing to prevent you making your own additions. The most important thing is to take some painting or drawing about which you can speak with conviction, explaining how and why it turned out as it did.

University Art Courses

The procedure for admission to faculties of art in universities is different from that for polytechnics and art colleges. You obtain application forms from whichever institution you are attending, or directly from: The University Central Council on Admissions, PO Box 28, Cheltenham, Gloucestershire GL50 1HY.

In most cases you must return the form by mid-December. You have six choices. There is a folio inspection scheme, and you can find out about this by writing to your first choice of university. Interviews take place in mid-February. The following universities offer degrees in various art subjects, and you should write to them to obtain further details of the courses available.

Bristol. Faculty of Art, University of Bristol, Bristol BS1 5PU.
East Anglia. University of East Anglia, Norwich NR4 7TJ.
Essex. University of Essex, Wivenhoe Park, Colchester, Essex CO4 3SQ.
Kent. University of Kent at Canterbury, Canterbury CT1 3AN.

Lancaster. University of Lancaster, Bailrigg, Lancaster LA1 4YW.
Leeds. University of Leeds. Leeds LS1 3HE.
London. Slade School of Fine Art, University College, Gower Street, London WC1E 6BT.
Oxford. Ruskin School of Drawing and Fine Art, University of Oxford, 74 High Street, Oxford.
Reading. Faculty of Fine Art, Whiteknights, Reading RG6 2AH.
Sussex. University of Sussex, Falmer, Brighton BN1 9RH.
Warwick. University of Warwick, Coventry CV4 7AL.

If you have been accepted for a degree course and have not had a grant before, you should be entitled to a mandatory grant, supplied by the local authority, whose Education Officer will supply you with information and the appropriate forms, if you cannot obtain them elsewhere.

The extent of the grant is determined by your own income (together with that of your spouse, or parents). The position is quite a complicated one, and it is most important to apply quickly and to seek all possible advice from the registrar or other appropriate officer at the institution which has accepted you.

Postgraduate Study

The next stage up the academic ladder is postgraduate study, which can mean another four or five years if you undertake research to PhD level. The funding for this

comes in varied forms. It is possible that you may qualify for the very limited number of bursaries or studentships available from the Department of Education and Science. Others may be awarded by the institution to which you apply, and discretionary awards are made by local authorities. Some postgraduate institutions operate a part-time approach, and you can work on a project while supporting yourself by other means.

The most prestigious postgraduate institution is the **Royal College of Art**, Kensington Gore, London SW7, which awards MAs and PhDs. Funded by the Department of Education and Science, its main accent is, especially recently, on design subjects, though it is also renowned for the many artists of distinction, from Henry Moore to David Hockney, who were students there.

Apart from the quality of the teaching, the Royal College operates a remarkably effective publicity machine on behalf of its students and it is extremely good at finding work for them, since it has contacts in all the right places. It also has access to a number of funds, endowments, foreign travel grants and the like. Painters and sculptors apply for acceptance in the August after they have graduated at their first-degree college, to commence in the following autumn.

The great rival to the Royal College in postgraduate art studies is the Slade School of Art, which is part of University College, London, and which also runs first-degree courses in fine art. The Slade has always emphasized fine art, partly because of the reputation it acquired in the first quarter of this century, when its students included artists such as Augustus John, Stanley Spencer, and the artist members of the Bloomsbury set. You may be able to obtain application forms for the Slade from your first-degree college, but, if not, write directly to the Secretary at the **Slade School of Fine Art**, University College, Gower Street, London WC1. Applications must be returned by 15 February, portfolios submitted by 4 March, and interviews take place in April and May.

Postgraduate courses are not confined to the Royal College and the Slade. There are several others under the ultimate control of the Council for National Academic Awards (CNAA), which are intended to extend a student's artistic experience by a more analytical approach to his or her work than practised at degree level, or by adding to this original first-degree experience a knowledge of another subject, e.g. art history.

A postgraduate course will normally include the presentation of a 'substantial dissertation', but in the case of fine art the assessment procedure will include a viva voce examination, especially when the student has undertaken an extended or ambitious artistic work, or if he or she has not presented a written account of the project.

Some postgraduate courses are part-time, which can, of course, be of great advantage to artists who spend most of their time in other activities but who, perhaps having graduated some years ago, are anxious to recharge their batteries and acquire an additional qualification or skill which may be useful in, for example, teaching. However, part-time

courses tend to vary considerably, and so care should be taken to select one that is going to be right for you.

The normal entry requirement for a postgraduate course is an honours degree, or a professional qualification recognized as being equivalent – and here there is a tendency for a certain amount of latitude to be given to older aspirants. The CNAA itself does not impose a minimum requirement based on the class of the first degree, although most institutions themselves prefer applications from candidates with a first- or high second-class degree, and it is difficult to get a grant without such a degree.

Grants for postgraduate courses come directly from the Department of Education and Science, and are more limited in number than those available from local authorities. Your best approach is to contact the institution you have chosen, find out if they will accept you, and then ask their advice about grants. Application for acceptance on a course should be made to: The Art & Design Admissions Registry, 24 Widemarsh Street, Hereford HR4 9EP.

Forms are available either from first-degree colleges or direct from the Registrar in early January. Completed forms should be sent to the 'first choice' institution by 25 January. Further details are available from the relevant institutions, and it is worthwhile finding out from them the finishing date of the courses, as some may continue into the next year.

The following list of institutions includes postgraduate courses in subjects other than fine art, on the assumption that some graduates holding a first degree in fine art may wish to extend their work into other related fields.

City of Birmingham Polytechnic, Fine Art, MA, one year full-time.
City of Birmingham Polytechnic, Graphic Design, MA, one year full-time.
Brighton Polytechnic, Printmaking, Diploma, two years part-time.
Leicester Polytechnic, Graphic Design, MA, one year full-time; Diploma, two years part time.
London, Central School of Art and Design, Graphic Design, MA, one year full-time.
London, Chelsea School of Art, Fine Art, MA, one year full-time.
London, Goldsmiths College, Fine Art, MA, two years part-time.
London, Wimbledon School of Art, Printmaking, Diploma, two years part-time.
Manchester Polytechnic, Fine Art, MA, one year full-time.
Manchester Polytechnic, Graphic Design, MA, one year full-time.
Newcastle upon Tyne Polytechnic, Fine Art, MA, two years part-time.
South Glamorgan Institute of Higher Education, Ceramics, MA, one year full-time.
Stoke on Trent, North Staffordshire Polytechnic, Ceramics, MA, two years practical and academic course.
Ulster Polytechnic, Fine Art, MA, one year full-time.

Alternative Courses

The progression from a Foundation course to a doctorate in art is, of course, not the only way of achieving an educa-

tion in the subject. There are a number of institutions which offer courses in which the student can take a degree encompassing a wide selection of subjects, most of them lying in the area of humanities (language, literature, etc.). The following institutions include fine art among the subjects on offer:

Cambridge, College of Art and Technology.
Canterbury, Christ Church College of Higher Education.
Chelmsford, Institute of Higher Education.
Chester, College of Further Education.
Crewe and Alsager, College of Higher Education.
Derbyshire College of Higher Education.
Exeter University.
Lancaster University.
Lincoln, Bishop Grosseteste College.
Liverpool, City College of Higher Education.
Manchester, College of Higher Education.
Northampton, Nene College.
Oxford Polytechnic.
Portsmouth, College of St Mark and St John.
Reading, Bulmershe College.
Roehampton Institute of Higher Education.
Wakefield, Bretton Hall.
York, College of York and St John.

There are also what might be termed 'vocational' courses, which do not lead to a degree but which are suitable for people who do not want to undertake concentrated study for three or four years. Most students who opt for this kind of course, which is usually of two years' duration, choose one in their own locality, and this makes it considerably easier to get a grant from the local authority. Vocational courses can lead to various qualifications, such as from a professional body like the City and Guilds. On the whole, however, vocational courses are in the design and 'functional' areas.

There are also several colleges which give their own diplomas, especially in the London area, the most outstanding being Byam Shaw School of Art, 70 Campden Street, London W8 7EN, which offers three-year and short-term courses. Another is Heatherley School of Fine Art, Old Ashbuoran, Upcerne Road, London SW10, which was founded in 1845, and offers courses of various kinds and different durations. Schools of this kind are a good deal more relaxed than those involved in the examination structure. You should apply directly to the schools for details of the courses they offer and grant availability.

In addition to the above there are a large number of private art schools, many of them offering residential courses both here and abroad. Some advertise in the national press, but the best source is the advertising and editorial pages of *The Artist* and *Leisure Painter*, both monthly magazines which can be obtained from most newsagents or from the publishers at 102 High Street, Tenterden, Kent TN30 6HT. Individual artists also give lessons. These private courses can be expensive and are no real substitute for a proper course at a recognized institution.

Studio Accommodation

If you decide to try to make money out of art, the first thing you will need is somewhere to work. Although having a studio in an 'arty' area is some people's idea of heaven, many artists leaving full-time art education find themselves instead in cramped and noisy accommodation, and unable to afford any sort of outside studio, while others simply prefer to work at home.

Whatever your situation, however, there is no need to feel that you must set yourself up in a 'collective' (a studio unit rented by a group of artists) or individual studio before you are able to work – given some peace and quiet, there's no reason why you can't produce a masterpiece on your kitchen table or in your garage.

However, if you decide a proper studio is the right working environment for you, first of all you need to establish exactly what you require. For example, will you want to live and sleep in the studio (like the romantic artist's garret)? What size should it be? Do you need natural light to work? What facilities do you need? What can you afford? Should you rent or buy?

All sorts of places could make suitable studios, from rooms above shops to new industrial units. But bear in mind that the cost of converting, say, a derelict warehouse into a studio could cost a lot of money. In cases of long-term occupancy, however, you may be eligible for a grant from your Regional Arts Association towards this cost.

EXHIBITING AND SELLING

The most important consideration for any artist is to get his or her work exhibited. This may sound obvious, but it needs constant emphasis. There are those, especially if they do not entirely depend on their art, who become very complacent about this – although it is quite wrong to do so. Without exhibiting you clearly are not going to be able to sell anything, except very occasionally through private contacts. Even more to the point, your work is not going to develop. It is only when you expose your paintings to public view that you will ever see them with any degree of objectivity.

Don't fool yourself that great artists don't care whether or not they exhibit. Cézanne, who is usually taken as an example of the modest, diffident type of painter, took great pains to get his works shown, bombarding the authorities who organized the Salon with angry letters. Even in his maturity he expressed great joy to his friends whenever he heard that one of his works had been shown in an exhibition.

Exhibiting your paintings, on whatever scale, is an act of faith. It is also an act of communication, and you should do everything you possibly can to explain what your art is about – an awful lot of people who claim to know about art are often bluffing, and would welcome the chance to be informed and reassured.

Getting the Best Return

There are a large number of venues where artists can exhibit their work, ranging from the Tate Gallery to the local art society's annual exhibition; from a prestigious West End gallery to an unoccupied shop in a small town High Street. Within each category there is an opportunity to exhibit a large variety of types and styles, ranging from the traditional to the experimental. Your main objective, therefore, is to try and find somewhere that best suits your particular ambitions and your type of work.

It is, of course, easy to make generalizations about where to exhibit, but you may find it helpful to refer to the invaluable report *The Economic Situation of the Visual Artist*, published by the Gulbenkian Foundation in 1985, which gives figures relating to the variety of venues available and their comparative contribution to artists' income. No artists ever find a sole outlet which can be guaranteed to give them the maximum selling potential, and it is essential to try as many individual galleries and as many combinations as possible. People are limited by their style of art, by where they live, by their expectations (e.g. do they want their art to form a subsidiary or a main source of income?), and by a host of other considerations. No guide can provide specific information tailored to all individual requirements.

Provincial galleries, for instance, sell a

higher percentage of the works they exhibit than do London galleries; but on the other hand, whereas in 1979/80 (the last year for which these figures are available) fifty-one London galleries paid out close on £5 million to their exhibitors, the equivalent sum for all provincial galleries was only £2.5 million.

There is no set formula about how to approach prospective galleries. The director of a commercial gallery, for example, may need to be swayed by different arguments to those used on an Arts Council official. There are, however, certain basic rules which are applicable when approaching most of the various outlets described in the following pages.

- Make sure the gallery still exists. There is a huge turnover of small commercial galleries.
- Make sure that the gallery or exhibition is suitable for your kind of work.
- Be accurate about things such as the names of the organizers or owners, the address, the sending-in days where relevant, and the documentation to accompany the works.
- Have available a curriculum vitae and a statement about your artistic beliefs, though this should be brief and pertinent.
- Check on all the relevant practical and financial details, such as insurance, VAT, copyright, etc.
- Make sure that you have an ample stock of colour transparencies or black and white prints for publicity purposes.
- Be very meticulous about packing and transportation. If you send transparen-

cies by post, use Registered Mail, and send a stamped addressed envelope for their return.

Commercial Galleries

Commercial galleries play a central role in the contemporary British art world. As recorded in the Gulbenkian report, every year they pay out large sums to artists, exceeding many times over the annual amount expended by the Fine Arts section of the Arts Council. They exert a great influence on the tides of artistic fashion, and they can certainly make an artist's reputation. Run for the most part by professionals, they have wide contacts in many spheres. They are usually adept at public relations and publicity, and know when and where to advertise an exhibition.

Also, and very importantly, they are skilled in deciding an artist's price range; and their staff are versed in the specialized technique of selling works of art. Some of them have branches or connections with other galleries in Europe and the USA, and participate in International Art Fairs such as those at Kassel, Bologna and Madrid – so giving their artists a wide international exposure.

Any professional artist who wants to make a success of his or her career, and maintain it, must have a relationship with one or more commercial galleries. Many galleries do not confine their interests only to artists of established reputation. Most of them are constantly on the lookout for new talent, for therein lies their whole future development. No commer-

cial organization can survive on its past, and as more pictures are sold, or rise into the museum category, there is a constant need to keep replenishing the supply of saleable artists.

The more successful West End galleries keep quite large stocks of contemporary art – laying down an investment, as it were, until it 'matures'. Commercial art galleries vary a great deal in the kind of work they show – paintings which would be shown by Waddington would not be popular with Agnews or the Fine Art Society – and also in status and reputation. There are more than 2,000 commercial galleries in Britain, and the top twenty (or thereabouts) are situated in London, clustered around the Cork Street/Bond Street area.

These galleries sell a larger proportion of their works to foreign buyers and institutions than do their less grand contemporaries. Along with specialist organizations such as Art for Offices (see pp. 117-18, *Useful Organizations*), they also deal a lot with the business market, which consists of large firms and corporations who may buy contemporary art either for aesthetic or for fiscal reasons.

Such galleries have an 'exclusive' relationship with about a quarter of their artists. This usually involves paying a retaining fee and having a consequent lien on everything the artist produces. Probably because of their sophisticated salesmanship (and their reputation), a large proportion of their sales are to first-time buyers. It is worth noting that less than half of their sales are of contemporary British art.

Approaching a Gallery

Unless you are very lucky there is little realistic hope of being taken on by one of the top-ranking galleries until you have established a sizeable reputation. But you should not be discouraged by this. Smaller galleries, both in London and the provinces, pay a great deal more attention to aspirants than their more prestigious counterparts, and in many cases at least three quarters of their income comes from the sales of works by living British artists. The owner of such a gallery is usually on the premises, is in most cases easily approachable, and is likely to have a very useful range of contacts.

Establishing a relationship with a dealer who will exhibit your works is of primary importance. Art dealers are neither starry-eyed idealists, nor rapacious monsters preying on innocent artists. A large proportion started off at art school themselves, some have degrees in art history or related subjects, and nine times out of ten have a great concern for and interest in art.

In your dealings with a gallery, avoid the extremes of boastfulness and self-doubt. Many artists seem to fall into one of these camps, but neither trait is appreciated, nor will get you very far. Instead, always emphasize the practical and business-like aspect of the relationship between yourself and anybody who is concerned with buying or displaying your works.

Getting to know all the art galleries in your area is a prerequisite to an approach to any specific gallery. That approach may take several forms.

Although you may prefer to turn up unannounced with a portfolio of drawings, watercolours or prints, this is inadvisable, as the appropriate person may not be in, or may be involved with a client, or otherwise engaged. In any case it is impractical to appear at a gallery with a bundle of unwieldy canvases.

The best approach is, of course, through a contact; but failing this a phone call or an initial letter is recommended. Explain your background, emphasizing any success you may have had at art school or elsewhere, listing any exhibitions in which you may have had works, the names of any previous purchasers, and of course any coverage you have had in papers or magazines.

You can then follow up this enquiry with slides of your work and any relevant publicity material, which may say something about the nature of your work, the ideals which motivate you and so on.

Reproductions of any kind can, of course, give a distorted or inaccurate representation of works of art (the very difference in scale or texture is confusing); but galleries almost always want to see slides first, so send them and then suggest that you make an appointment to bring along a selection of works at a mutually convenient date.

Getting Down to Details

Success at this stage can take several forms. One possibility is that the dealer will take some of your works. He may buy them outright, which, though satisfying, is not a good thing in the long run, since you have lost control of their eventual pricing and indeed of their fate.

It is more likely that you will have a sale or return arrangement, by which the dealer will take a number of your works and sell them if and when he can, perhaps in a mixed exhibition, taking a commission which will probably be quite high in the case of an unknown or little known artist – up to as much as 50 per cent for some of the top London galleries.

But pricing is not everything. A whole range of other things must be arranged. For example, does the dealer prefer to show paintings in his frames, or does he want them framed at all? How long will he keep them? How and when will you know if a sale takes place? Who will pay insurance (usually galleries are covered by an umbrella policy)? Can the dealer lend your works to other dealers on a sale-or-return basis? Can he lend them out to potential buyers on a 'take it home and see how it looks on your wall' arrangement? What happens if you introduce a potential customer, who subsequently buys one of your works? What about reproduction rights? Is the dealer registered for VAT?

All these questions should be asked in the course of your discussions with a dealer. Bear in mind that when a dealer is taking you on for the first time, until he has sold some of your works you are the weaker partner in the relationship.

Mounting an Exhibition

The next and most rewarding stage in your relationship with a dealer is the holding of a one-person exhibition. Do not

expect this too soon. Dealers usually plan their exhibitions a year, or sometimes two years in advance – a fact for which you will probably be grateful, especially if you have another job. The amount of work involved in mounting an exhibition, even with the help of gallery staff, is enormous.

The first and most important thing is to formulate the arrangements for the exhibition either in the form of a contract or by a less formal, but still documented agreement. This will cover the points mentioned above. Other details to be agreed include the dates and duration of the exhibition; how many works will be included; who (where relevant) will pay for transport; what will the artist be required to contribute in the way of supplementary material; who will pay for the catalogue and the private view; who will be responsible for publicity; and will the artist have any control over it? The more details that are settled in advance, the less chance there is of subsequent misunderstanding.

Next, you need to choose what is going into the exhibition, and this should be a joint operation in which you should be ready to accept the advice of the dealer. A question you may wish to consider is whether or not to include one or two works which have already been sold, with a notice in the exhibition catalogue 'Lent by so and so' or 'Not for Sale: On Loan from a Private Collection'.

Remember that a few red spots on the pictures in an exhibition are as contagious as measles – they encourage other people to buy. In fact, some artists arrange for one or two of their pictures to be 'bought'

before the exhibition actually opens. But consult your dealer about this.

Having chosen your pictures, decide on which, if any, you are going to have photographed for publicity purposes. As far as art journals go, illustrations usually end up being used in black and white, although some of the more prestigious magazines use full colour as well as black and white – and of course if you are lucky enough to get a mention in one of the Sunday magazines, they will undoubtedly reproduce your work in colour.

As a rule, colour reproduction is prohibitively expensive for most tightly budgeted art journals, although, on the bright side, local – and national – newspapers increasingly have facilities for doing colour work. Also, you can always use a colour picture on the cover of a catalogue, and in any publicity material you may send out you can say 'colour reproductions available'.

It is more than likely that your dealer will see to all this, but it is possible that he may not, and that the cost of doing so will be your responsibility. In any case it is always a good idea to be aware of what is involved, as at some time you could be in the position of organizing your own exhibition without a dealer's help.

Initial Publicity

Invitations or notices of the exhibition should be sent out about a month in advance (to monthly magazines about six weeks before the opening, as they are planned and compiled a considerable time before their publication date).

Remember that when you have something printed, the largest portion of the expense is the initial design, typesetting, colour separation and planning – once it is ready and the first, say, thousand are printed, the run-on price per thousand will be comparatively inexpensive.

If you are responsible for producing a catalogue of your exhibition, it can vary in format from a glossy production with colour reproductions to a much more modest document that is typed, photocopied and stapled together. It should contain the following elements:

- The basic information, place, title, opening times, etc.
- Brief details of your career, any previous exhibitions, etc.
- A statement of some kind about your art – anything that will give readers a clue as to what to expect. If you know anyone of standing (not necessarily in the art world) who will write 800 words or so about you all the better.
- Most importantly, a list of the works, with the medium indicated where this is necessary. There is a widely accepted convention not to give the prices in the catalogue, but to have them available on a separate sheet.

Hiring Exhibition Space

There is another way of achieving an exhibition at a gallery, and that is by paying for it. Some galleries are quite open about this, and advertise the fact that they can be hired for a fee – usually not inconsiderable. Other arrangements are more complex. Some galleries will agree to show your works for a percentage fee, although to cover their overheads you will have to guarantee the sale of works up to a certain sum – and if you don't achieve that amount you will have to pay them a penalty fee.

In addition to commercial galleries there are several public, or semi-public, institutions which rent exhibition space, usually at a fairly modest fee. Here is a selection of both kinds. A full list can be found in the extremely useful *Directory of Exhibition Spaces*, published by Artic Publishing Ltd.

BARNET
Old Bull Gallery. 68 High Street, Barnet EN5 5SS.
Some 40ft of hanging space. A negotiable rate and a commission of 20% is charged, with the gallery meeting the cost of printed publicity, private view and catalogue.

CARDIFF
John Owen Gallery. 134 Albany Road, Cardiff.
Tel. 0222 487422.
A private gallery showing nineteenth-century paintings and drawings. Can also be hired from £65 a month.

CHELTENHAM
Pedlars Gallery. Carol Adams, Pedlars Gallery, Crescent Place, Cheltenham GL50 3PH.
Tel. 0242 54480.
A private gallery hiring out purpose-built stalls, or the whole gallery, for exhibitions. Commission is 20 per cent, and the gallery covers insurance, publicity, mailing and

catalogue, and shares the cost of the private view.

CHEPSTOW
Old Bell Galleries. Pat Harvey, Old Bell Mews, Bank Street, Chepstow NP6 5EN. Tel. 029 123 400.
Space available for an exhibition of about thirty paintings. Commission of 33 per cent. Professional artists only accepted.

COLCHESTER
The Arts Centre. St Mary-at-the-Walls, Colchester CO1 1NF.
60sq m of exhibition space rented out for a negotiable fee, plus a commission of 25-31 per cent. Meets the cost of insurance and mailing and shares the cost of publicity.

EDINBURGH
Calton Gallery. 10 Royal Terrace, Edinburgh EH7 5AB.
Tel. 031 556 1010.
The home of the Whitfield family, with 150 ft of wall space for exhibitions usually given over to nineteenth- and twentieth-century art, but it may be hired for a maximum of two weeks at a negotiable fee, sharing the costs of the publicity. The gallery pays for other incidentals.

Saltire Gallery. Saltire House, Atholl Crescent, Edinburgh EH3 8HA.
Tel. 031 228 6621.
Can be hired for around £50 a week or 20 per cent commission realized on sales, whichever is the larger. The artist pays all expenses.

HENLEY
Henley Exhibition Centre. Market Place, Henley-on-Thames RG9 2AQ.
Tel. 0491 26982.
1,000sq ft of exhibition space with natural and artificial light.

LONDON
The Alpine Gallery. The Secretary, The Alpine Club, 74 South Audley Street, London W1X 4DA.
Tel. 01 499 0314.
An extensive gallery in the heart of Mayfair, owned by the Alpine Club. The artist has to assume full responsibility for invigilation, etc., and opening times can be arranged to suit his or her convenience.

Burgh House Trust. Victoria Heyland, Burgh House, New End Square, London NW3 1LT.
Tel. 01 431 0144.
An eighteenth-century house, which in addition to rooms for concerts, etc., houses a fairly large exhibition space for hire. Proposed exhibitions have to be approved by the management committee.

The Guild Gallery. John Mountford, Fine Art Trade Guild, 192 Ebury Street, London SW1Y 8UP.
Tel. 01 730 3220.
Owned by the Fine Art Trade Guild, this is a 34 × 13½ft gallery for hire. Exhibitors are responsible for all their own arrangements.

Joanna Woodward Gallery. 166 Victoria Park Road, London E9.
Tel. 01 986 4274.

A converted shop with 350sq ft of exhibition space which can be hired cheaply.

Lasson Gallery. 34 Duke Street, St James's, London SW1Y 6DF. Tel. 01 930 5950.
A commercial gallery dealing in contemporary art, which lets its exhibition space to artists for a fee. Prestigious position.

Leighton House. The Curator, Leighton House, 12 Holland Park Road, London W14 8LZ. Tel. 01 602 3316.
The property of the Royal Borough of Kensington. Though dedicated to the memory of its first owner, that well-known Academician Lord Leighton, it has three extensive galleries with hanging facilities on battens, which are let on a weekly basis. All additional costs are the responsibility of the artist.

7 Dials Gallery. 44 Earlham Street, London WC2. Tel. 01 240 5470.
Available for hire by individual artists' groups, this gallery offers 280ft of hanging space, with spotlights, in the heart of Covent Garden.

Public Galleries and Other Institutions

Public galleries, both national such as the Tate, or municipal such as the Walker Art Gallery in Liverpool, exhibit work by contemporary artists. On the whole, however, they tend to prefer pre-packaged exhibitions arranged for them by the Arts Council or some other body – sometimes even by commercial galleries.

There are, of course, exceptions, especially among the smaller municipal galleries, which are often persuaded to put on exhibitions of work by local artists, or work which has a regional or local interest.

Every local authority receives a proportion of funds for running museums and art galleries, though how it apportions these funds is its own responsibility and obviously varies a good deal. In addition, there are various means by which it is able to boost its patronage of living artists.

Those galleries run by local authorities which belong to the Contemporary Art Society can choose a work from the Society's collection, though that will only help you personally if you have already had a work purchased. Galleries may also apply for a grant for specific purposes from a central government fund administered by the Victoria and Albert Museum in England and Wales, and north of the border by the Royal Scottish Museum. The monies from this fund are available on a first come, first served basis. Only a certain amount is available each year, and the contribution from the fund is matched by an equal amount from the gallery itself.

Policies of Municipal Galleries

The policies of individual municipal galleries vary greatly both towards exhibitions and purchases. The Mappin Gallery in Sheffield, for example, welcomes applications from individual artists or groups, provided that the work is stimulating and fits in with the overall

exhibition programme. The Laing Art Gallery in Newcastle, on the other hand, does not accept applications; whereas Bolton Museum and Art Gallery 'wishes to encourage practising artists and crafts-people in the region' and is happy to receive suggestions; and nearby Black-burn states emphatically that it depends on applications for its exhibition pro-gramme.

One thing is certain: it never does an artist any harm to keep in touch with what his or her local authority is doing in the sphere of the arts. Most of them spend money on purchasing or commissioning works of art for public buildings, for use in schools and other such institutions, and in some cases they employ 'community artists'. As well as certain London boroughs such as Lambeth, Camden and Lewisham, which have an extensive system of patronage, there are several provincial authorities which spend a good deal in this area.

One of the most outstanding of these is Leicestershire, which since 1969 has been spending 0.25 per cent of the cost of any new building it erects on the provision of sculpture and paintings for that building. It also owns a considerable collection of contemporary works of art – some 600 – which are circulated through educational establishments. These have been bought from the monies accrued from royalties paid on works written by council officers as part of their official duties. Leicester-shire also organizes an annual sale of works of art at which schools and colleges are encouraged to make purchases out of their own funds.

Leicestershire in fact has used con-siderable bureaucratic ingenuity to chan-nel funds into actually buying works of art from living artists, and you should explore all the potential of such a source of pat-ronage in your own area by contacting the Chief Education Officer, the Chief Lib-rarian or the Chairman of the Arts and Libraries Committee.

Leicestershire is not unique. In Notting-hamshire, for example, a work of art is bought for each new library built. Greater Manchester Council commissions murals, some of them in conjunction with the Job Creation Scheme, and on one occasion engaged an artist to produce thirty-five paintings and drawings depicting ten areas of the city and its inhabitants. Each year Essex commissions a member of the Society of Portrait Painters to produce a portrait of the retiring Council Chairman.

Another interesting and potentially helpful activity of many local authorities is running picture-loan schemes. These vary a good deal in their scope and range. In Ealing, London, for instance, the library service buys works of art which are lent to schools; in Islington they are lent to lib-raries and other council-owned institu-tions and buildings.

Barnet, on the other hand, has built up a collection of paintings, drawings and prints housed in North Finchley Library, items of which can be borrowed by members of the public at a nominal fee for three months. Nearby Camden also lends out works of art on the same principal.

Since the sums at the disposal of authorities such as these is comparatively small, they are likely to look for new

acquisitions in the £50-£200 price range. Several librarians who run such schemes have indeed professed themselved eager to have suggestions from artists. An added incentive for the artist, of course, is the fact that a borrower, having become accustomed to a work on his or her living-room wall, might wish to buy another work from the artist.

Art Centres

Another range of institutions is concerned with exhibiting works in collaboration with bodies such as the Arts Council and Regional Arts Associations, as well as with private patrons and art-inclined commercial organizations. These institutions have developed since World War II and cannot be defined by any specific generic name, though some title like 'Art Centres' is a fair description.

Their activities are not restricted to the visual arts, and may include cinema, theatre, etc. They present a wide range of opportunities for an artist to publicize and possibly sell his or her work, and are a most useful point of contact.

Like all information of this kind, their particulars are contained in the *Directory of Exhibition Spaces*. An idea of the nature of these institutions can be gained from the following representative samples.

Arnolfini Gallery. Narrow Quay, Bristol BS1 4QA. Tel. 0272 299191.
One of the most ambitious institutions of its kind, and one of the most successful, the Arnolfini, which is supported by a variety of organizations as well as by its own economic efforts, mounts ten large and ten smaller exhibitions a year. It consists of an auditorium seating 150, where performance art may take place, a restaurant which is also an exhibition area, a bar, cinema and bookshop and an open-air sculpture park covering 50sq ft.

The Arnolfini has attracted international attention, but also offers opportunities for those artists who are on the way up. It has an active educational programme, a print loan scheme, a schools' placement scheme (limited to the south west), and acts as an agent in finding commissions for artists. The gallery is prepared to accept applications for exhibitions, provided that they are accompanied by adequate documentation.

Camden Arts Centre. Arkwright Road, London NW3 6DG. Tel. 01 436 2643.
Contains three galleries, giving a total hanging availability of 388 linear ft, as well as a small garden used for sculpture exhibitions. There is also a coffee bar and foyer. Artists are welcome to apply for exhibitions. The gallery charges a commission of 25 per cent but meets all expenses except travel. There is an active educational programme plus other activities.

Fermoy Centre. King Street, King's Lynn, Norfolk PE30 1HA. Tel. 0553 4725.
110 linear ft of hanging space. Funded by the Regional Arts Association, the local authority and private support, it invites applications for exhibitions, charging 33 per cent commission, with the gallery meeting all expenses. The Red Barn, an ancillary gallery, is also available for hire.

Museum of Modern Art. 30 Pembroke Street, Oxford. Tel. 0865 722733.

Housed in an old warehouse, the museum contains seven galleries, with extensive and sophisticated lighting systems. As its name implies, it is almost exclusively concerned with contemporary art, and this concern shows itself in two forms. One is exhibitions of distinguished artists of our time who have an international reputation; the other is the display and promotion of the work of living British artists, usually in the form of one-person shows.

The museum has admirable back-up services, educational programmes and close contacts with the University.

Third Eye Centre. 350 Sauchiehall Street, Glasgow G2 3JD. Tel. 041 332 7521.

A multi-media arts centre, which has two large exhibition galleries and a foyer which is also used for displays. It also has a restaurant, bar and bookshop, and runs a lecture and film programme. It has a natural inclination to Scottish art, but not exclusively so. Most of the exhibitions are by invitation, though applications are welcome.

Development Corporations

The foundation of new towns over the past twenty-five years or so has spawned a new type of civic institution, the Development Corporation, which is concerned with the creation of new urban centres. Part of its responsibility is the establishment of a cultural environment which will enhance the quality of life in such areas.

This tendency became established some time ago. Between 1954 and 1977 Peterlee Development Corporation employed Victor Pasmore as a visual planning consultant. He was involved in the design and layout of buildings, in providing works of art such as sculpture and murals, and advising generally on such matters as the choice of textures and colours.

In more recent times, Livingston Development Corporation in Scotland employed a 'town artist', whose brief was to function as an artist in his own right, to act as a consultant on design matters, and to establish a presence for art in the community. He was able to employ on a part-time basis no less than twenty-five young artists, and he and his team produced murals, sculpture, street furniture and equipment for childrens' playgrounds.

In Harlow New Town, an independent charitable trust was set up, which included representatives of the local citizenry as well as 'experts', and which acquired some thirty pieces of sculpture and other works. Bracknell Development Commission has commissioned a number of artists to carry out works, usually in collaboration with an architect.

Milton Keynes has shown great initiative, not only by commissioning works from artists such as Elizabeth Frink, Wendy Taylor, Stephen Greenberg and John Watson, but by creating exhibitions for placing art in offices, factories and public areas, as well as initiating a 'Prints for People' rental scheme, which has been subsequently taken over and run by the Buckinghamshire County Council Library Service.

It is clear that these corporations are a potential source of patronage, and if you have any convincing scheme or project do not hesitate to approach them. A list of Development Corporations with their addresses and the names of their principal officials can be found in *Whitaker's Almanack*, copies of which are available in all public libraries. This is, incidentally, an invaluable reference book, published annually and giving particulars of all government offices and other institutions.

Libraries

There are more public libraries in Britain than any other type of cultural institution. Practically all of them have wall space which can be filled with pictures, and a large number of them are more than happy to mount exhibitions – though attitudes, and costs, vary widely from region to region.

Leicestershire Public Libraries, for instance, which has ten sites for showing pictures, makes no charge at all. Cambridge Central Library on the other hand exacts a commission of 10 per cent, while Bedford Central Library charges a nominal fee per picture and will accept works of art in lieu of payment.

Amesbury Library, near Salisbury, charges the eccentric commission of 12½ per cent, while at Basingstoke, which has a ground floor exhibition room measuring 36 × 36ft, space is given free, provided that the exhibition is 'non-commercial'. Scarborough Central Library makes a similar stipulation, but also charges 'according to status'. At Pendle

the 10 per cent commission covers the cost of a catalogue; and some public library systems, such as those in Cheshire, having accepted an exhibition, are prepared to tour it through some fifteen or sixteen branches.

Libraries are in fact part of an often quite complex local government organization which includes museums, galleries, schools, leisure services and similar departments, all of which have exhibition potential. In many local authorities this aspect of their services is co-ordinated (as in Kent) by an Arts and Exhibitions Officer. He or she is a person worth contacting, if there is one in your area, as the Officer's mere existence suggests a full exhibitions programme – and probably a rigorous selection process.

There are very many advantages in exhibiting at a public library. It is cheap, often free, and it will be seen by a great number of people. The atmosphere is relaxed, most libraries are open at times when the maximum number of people can use them, and you will very likely get some publicity in the local paper, especially if your work has local relevance.

However, the drawbacks are also apparent. The library staff cannot sell your pictures, they have to put prospective purchasers in touch with you, and they do not usually have the time to talk to the public about the exhibits. Also, libraries are usually only interested in small shows; the hanging and general exhibition material can be inadequate; the prices you are likely to get must, realistically, be modest; and the risk of vandalism or theft is a real one.

It is essential, therefore, if you are exhibiting in a public library, that you should:

- Provide clear labelling of the works, and a typewritten statement of who you are, what your artistic ideas are, and anything about your choice of subject or style. Keep the whole thing to about 400 words.
- Provide a price list with a clear indication of where you can be contacted.
- Spend as much time as you can afford, or the librarian will tolerate, at the exhibition, chatting to people you see looking at the works.
- If you put a reasonable value on your works, make sure you have them insured.
- Discuss with the librarian possible forms of publicity, and whether it might be an idea for you to give a talk, or arrange a discussion in connection with the exhibition.

Universities and Other Academic Institutions

Universities and other institutes of higher education, such as polytechnics, art colleges, and teacher training centres could all be suitable for exhibitions, although sales may not be high. To some extent you have a captive audience, many of whom are interested in art.

Among staff members there are usually some who collect paintings, or at least buy the occasional one to adorn their homes. There is usually a lot of potential exhibition space, and in many cases actual art galleries. These institutions are often very

generous with incidental expenses, and are kindly disposed to opening parties. You might even get an invitation to talk about your work.

If you don't know anybody to approach, write in the first instance to the Vice Chancellor/Principal Secretary, or to the President of the Students' Union. Universities such as Oxford, Cambridge and London, which have constituent colleges, provide additional facilities, and the Junior Common Rooms of such colleges often have small exhibitions of, say, twenty paintings or drawings.

The following is a representative selection of those institutions which have their own art galleries.

University of Aston. The Triangle, University of Aston, Gosta Green, Birmingham B4 7ET. Tel. 021 259 3979. The Triangle functions as a sort of university arts centre, staging or showing different media. Exhibitions of paintings, prints and drawings (with a commitment to showing amateur and professional artists side by side) are put in the library foyer and in the coffee bar areas.

University of Birmingham. Department of Extra-Mural Studies, Birmingham University, Edgbaston Park Road, Birmingham B15 2TT. Tel. 021 472 1301. The Extra-Mural Department runs exhibitions as part of its educational policy, showing two or three exhibitions a term. It pays for publicity, insurance and a list of exhibits, the artist being responsible for transport and hanging.

Brighton Polytechnic Gallery. Faculty of Art & Design, Grand Parade, Brighton BN2 2JY. Tel. 0273 604141.
A considerable exhibition space devoted to works by contemporary artists, selection being by a jury composed of members of the Fine Art Faculty. A commission of 25 per cent is payable, but the Polytechnic covers all costs. There are also other smaller exhibition spaces available in the main Polytechnic building.

Cambridge, Kettle's Yard Gallery. Kettle's Yard Gallery, University of Cambridge, Northampton Street, Cambridge CB30 0AQ. Tel. 0223 352124.
A compromise between a university and a public gallery, which houses the collection of the Ede family. The gallery puts on a programme of temporary exhibitions, and welcomes suggestions (and slides) from artists.

Chesterfield College of Art & Design. Exhibition Organizer, Sheffield Road, Chesterfield S41 7LL.
A balcony area offering 160 linear ft of exhibition space is available from the beginning of the academic year in September until May, when the college's own exhibition goes up. Applications are accepted from individuals and groups.

University of Essex. Arts Administrator, University Theatre, Wivenhoe Park, Colchester CO4 3SQ. Tel. 0206 861946.
Exhibition space of one large room and two smaller ones available in the library and theatre area.

University of Durham. Arts Administration Department, Old Shire Hall, Old Elvet, Durham DH1 3HP. Tel. 0385 64466.
Various exhibition spaces are available throughout the university. Insurance and catalogue are paid by the university, publicity expenses are shared.

Edinburgh College of Art. Lauriston Place, Edinburgh EH3 9DF. Tel. 031 229 9311.
There are three exhibition areas available at modest hire rates.

University of Edinburgh, Talbot Rice Art Centre. The Curator, Old College, South Bridge, Edinburgh EH8 9YL. Tel. 031 667 1011.
Extensive exhibition space with frequent shows of contemporary art, with an emphasis on Scottish work. The Centre takes 25 per cent commission on sales, and negotiates other costs.

Keele University. Keele ST5 5BG. Tel. 0782 621111.
Runs a varied selection of exhibitions, and invites applications from artists to show their work. A commission of 10 per cent is taken, with other expenses determined by arrangement.

University of Leeds. Leeds LS2 9JT. Tel. 0532 431751.
One large and two small galleries provide space for regular exhibitions, some of which are chosen from applications.

University of Liverpool. Oxford Street, Liverpool L69 3BX. Tel. 051 709 6022.
Senate House Exhibition Hall accepts suggestions for any kind of exhibition during term. A 10 per cent commission is taken, and the artist pays all the expenses.

Polytechnic of Central London.
35 Marylebone Road, London NW1.
Tel. 01 580 2020.
The Concourse Gallery shows mainly mixed exhibitions, and is happy to receive applications from groups and individuals.

University of Manchester. Faculty of Art & Design, Cavendish Street, Manchester M15 6BR. Tel. 061 228 6171.
The John Holden Gallery measures some 250sq ft, with two smaller adjacent galleries. Selection by application and invitation, with the gallery assuming most of the costs.

Morley College. 61 Westminster Bridge Road, London SE1. Tel.01 928 8501.
An institution in the tradition of the Working Men's College of the nineteenth century where Rossetti and Ruskin taught. It runs classes in a wide variety of subjects, including most branches of art, and has an impressive gallery with 150 linear ft of exhibition space. It welcomes suitable applications and charges 30 per cent commission, sharing the costs of publicity with the exhibitors.

Norwich School of Art. St George Street, Norwich NR3 1BB. Tel. 0603 610561.
During term a gallery of some 160sq ft with spot and fluorescent lighting is available for exhibitions. A commission of 20 per cent is taken, but the gallery covers all reasonable expenses.

Preston Polytechnic. Head of Art & Design, St Peter's Square, Preston PR1 7BX. Tel. 0772 22141.
The Art & Design building has three exhibition areas which can accommodate exhibitions in term time, by invitation or application.

Sheffield University Library Gallery.
University of Sheffield, Sheffield S3 7RH. Tel. 0742 78555.
Holds about five exhibitions a year, and welcomes applications. The gallery charges a commission of 20 per cent, but covers all incidental expenses.

University of Surrey. Department of General Studies, University of Surrey, Guildford. Tel. 0483 505050.
Shows frequent exhibitions of work by contemporary artists.

University of Sussex. Falmer, Brighton BN1 9RA. Tel. 0273 685447.
Gardner Art Centre is a large gallery with foyer which accepts applications for exhibitions. The gallery takes 25 per cent commission and meets all expenses except framing and transit insurance.

West Surrey College of Art & Design, Farnham. Falkner Road, The Hart, Farnham, Surrey. Tel. 0252 722441.
An exhibition hall of 5,000sq ft is available for displaying the works of students, groups or individuals.

University of York. The Students' Union, University of York, York YO1 5DD. Tel. 0904 59861.
The Students' Union is responsible for an exhibition space in Heslington Hall, which features some eight shows a year.

Art Groups and Societies

Over the past few decades there has been a healthy proliferation of groups of artists – often bound together by a wide variety of political, social, stylistic, ethnic or religious ties – whose main purpose is to ensure the exhibition of their members' work either on an individual or a collective basis.

Less formal and tradition-bound than most of the older societies such as the Royal Watercolour Society or the New English Art Club, they tend to be more numerous outside London.

On the whole, their approach is a catholic one, and so they are particularly useful for younger artists and for those who adopt more adventurous art forms, though this is not always the case. Art groups also act as pressure groups, and are good places to discuss work and meet useful contacts.

The following list will give you some indication of the type and range of such organizations, and may spur you to look for one that suits you, or even to start one yourself! For a full list of the various groups and societies that may exist in your area, contact your Regional Arts Association.

Arteast Collective. 18 Claremont Road, Leyton, London E11 4EE.
A group of East London artists formed to pool resources and organize joint exhibitions.

Artists' Collective of Northern Ireland. ACNI, Queen Street Studios, 37 Queen Street, Belfast BT1 6EA. Tel. 0232 243145.
Aims to promote and articulate by various means the interests of artists living in Northern Ireland, including the promotion of exhibitions of members' works both inside and outside Ireland.

Artspace. 302 North Street, Ashton, Bristol. Tel. 0272 634416.
Now in its tenth year, Artspace organizes occasional exhibitions in the Bristol Docks Exhibition Centre on the other side of St Augustine's Reach to the Arnolfini.

Black Art Gallery. 255 Seven Sisters Road, London N4 2DA. Tel. 01 263 1918.
Non-profit-making organization offering permanent exhibition space to black visual artists.

Collective Gallery. The Artists' Collective Gallery, 52 High Street, Edinburgh EH1 1TB. Tel. 031 556 2660.
Run by artists to offer an alternative to established galleries in Edinburgh. Membership is open to all.

Dundee Art Society. Doreen Andrew, 16 Adelaide Place, Dundee. Tel. 0382 24767.
Has a gallery which charges a small sum per week plus 15% commission to non-members.

56 Group Wales. For information apply to the Fine Arts Department of the Welsh Arts Council, 53 Charles Street, Cardiff. Tel. 0222 395548.
Formed in the year of the century which gives the group its name, and supported by the Welsh Arts Council, it arranges exhibitions of works by members, both in Britain and abroad.

Leeds Art Space Society. LASS, Stowe House Studios, 5 Bishopsgate Street, Leeds. Tel. 0532 431427.
Holds open shows, sometimes in artists' studios, or in collaboration with other groups.

Manchester Artists' Association. Fiona Moate, Stonebridge House, 16-18 Granby Row, Manchester. Tel. 061 236 1078.
The association runs the Castlefield Gallery, and operates a friends' scheme, offering discounts on materials, etc. The group also runs life classes and workshops.

Middlesbrough Artists. Alison Brien, 62 Corporation Road, Middlesbrough, Cleveland. Tel. 0642 225376.
The group has studio space to let, and invites exhibition proposals for its premises in the centre of the town, which have 60ft of hanging space.

Norwich Artists Group. Contact the group through the Norwich School of Art, St George Street, Norwich.
The group was formed in 1980 around a nucleus of graduates from the Art School. It holds exhibitions, usually in conjunction with the Norwich Festival, and features an open studio scheme.

Nottingham Studio Group. 179 Wollaton Street, Nottingham NG1 5GE. Tel. 0602 819821.
A newly formed group, with a communal studio, which is working towards arranging exhibitions and contacts with other artists and groups.

Nucleus. 128 Bevois Valley Road, Southampton. Tel. 0703 224681.
The Southampton Artists' Collective, which runs a shop, gallery and educational centre.

Oriel y Ddraig. 1 Market Square, Blaenau Festiniog, Gwynedd. Tel. 076 683 1777.
An independent non-profit-making artist-run gallery which holds a series of changing exhibitions. Work from younger artists is encouraged.

People's Gallery. 71-3 Prince of Wales Road, London NW5 3LT. Tel. 01 267 0433.
800ft of exhibition space providing an outlet for artists and craftspeople who have attained a high standard, and who because of their race, sex or class are denied the opportunity to exhibit their work.

Union Chapel, Islington. Union Chapel, Compton Terrace, Upper Street, London N1. Tel. 01 359 1433.
A gallery in a Union Chapel recently restored by the Manpower Services Commission as a community centre. There is no selection committee, but artists who wish to exhibit here are asked that they should not include works which could be construed as obscene or anti-religious.

Women's Work. Brixton Art Gallery, 21 Atlantic Road, London SW9 8HX.
A collective of women artists which aims to provide exhibition facilities for women who are unable to exhibit elsewhere, including those who may be isolated or untrained, and those of various cultural backgrounds.

Open Exhibitions

Perhaps the least difficult way to get your work exhibited is through open exhibitions, run by art societies or other organizations. The general principle underlying these is that you submit a specific number of works, usually about three, to a selection committee, and pay a fee for each work submitted. This is to cover 'handling fees' and help subsidize the exhibition. Usually, but by no means invariably, a commission is charged on any work sold.

These exhibitions are of three main varieties: completely open exhibitions which take works in almost any style or on any theme; those which are confined to one medium (e.g. watercolour) or subject matter (e.g. marine, botanical, etc.); and those – probably the most numerous – which are confined to one geographical area (e.g. the exhibitions of the numerous local art societies, details of which can be found in local papers, libraries, etc.).

Royal Academy Summer Exhibition

The advantages of open exhibitions are manifold, and of all of them the best known and most successful is the annual Summer Exhibition of the Royal Academy. To many people the fact that a painting has been hung in this exhibition gives it a seal of approval which rubs off on all the other works of the lucky artist. It may therefore be worth examining the mechanics of this regular feature of the British art year a little more closely.

According to the Academy's Instrument of Foundation of 1768, it has the obligation of holding 'An Annual Exhibition of Paintings, Sculpture and Designs, which shall be open to all Artists of distinguished merit'.

Today, this is put into effect by giving all Academicians the right (not always taken up) to exhibit six works of art without submitting to a selection process, and in addition to this the RA opens the exhibition to anyone paying a fee of around £9, which tends to increase slightly each year.

The submitted works of art are selected for the exhibition by a panel of Academicians which varies each year. In 1987, some 13,000 works were submitted, an increase of 8 per cent on the previous year. Of these works there were 7,174 oil paintings, 3,620 watercolours, 1,438 prints, 159 miniatures, and 720 pieces of sculpture. Eventually 1,320 were chosen to be exhibited, about 10 per cent of those submitted.

Some idea of the advantages of exhibiting at the Royal Academy can be deduced from the fact that over £1 million worth of works was sold in 1987, and the exhibition was seen by 139,480 people. The Academy takes a 25 per cent commission on sales. Bear in mind that you may incur additional costs such as transport.

The Royal Scottish Academy has a similar annual exhibition.

Choosing the Right Exhibition

One of the most important considerations with mixed exhibitions is to be constantly on the look-out for those which are likely to suit your type of work. Then make sure

you get the application forms in time, fill them in correctly and deliver the works you submit at the right place and time; and likewise arrange to have them collected at the end of the exhibition.

You should always consider, too, whether on balance the entry fee and incidental expenses are worth it. Usually they are, but you may be disappointed.

Be wary of submitting work to mixed exhibitions outside Britain. They can present considerable problems with packing, transport, customs and insurance, and your works are probably less likely to sell abroad than in Britain.

The total number of open exhibitions in Britain is very large, and includes those of local art societies and those attached to professional bodies, for example the Army Art Society or the Law Art Society. Remember, too, that there is a whole category of open exhibitions which are in effect competitions, but also involve an exhibition of an entrant's works. There are also numerous one-off mixed exhibitions, organized on a specific theme, sometimes by a public art gallery, sometimes by a commercial or civic organization. Keep an eye open for these, even if they involve producing a work specifically for them.

Always contact the organizers of an open exhibition before submitting work. This is especially relevant in the case of the RA Summer Exhibition, which each January publishes a Notice to Artists giving full details of submission procedures.

It would also help you to take out a subscription to one of the art magazines (see p. 50) which contain a list of open exhibitions and other opportunities.

Alternative Ways to Exhibit Your Work

It would be unwise for any artist who wants to make money out of his or her work to limit the possibilities of exhibiting it to places specifically intended for that purpose. Art galleries, whether public or commercial, are a comparatively recent development in the history of art, and even today there are many successful and well known artists, especially those in the field of portraiture, who hardly ever have a public exhibition.

If you are an artist, you should look on your home or studio as a shop, or even, if you wish to add a touch of ostentation, a *bottega*.

If you have a large enough house, or perhaps a small house with some sort of outbuilding, you can devote part of it to a permanent gallery. Then you have to try and encourage a regular flow of visitors by asking people round to your home 'gallery' whenever you have the opportunity.

This can be done on a more organized basis by having a kind of open-house day (as many of the Victorian painters did), when you let it be known that you will be dispensing hospitality on a regular day each month, or at longer intervals. The more people who know you and your work, the more likely you will be to sell it, and to make some rewarding contacts into the bargain.

The advantages of selling work from your home are obvious. You have no expenses beyond those of framing and hospitality, and there is no commission to

pay. If you live in an 'arty' area, or have artist friends in your neighbourhood, you can always take it in turn to play host or arrange tours of studios. Indeed, Oxford, Leicester and many other towns now have 'Artweeks', which are annual events based on open studios.

Restaurants and Stores

Outside your own home, there are other places where, by using your own initiative, you can show your work virtually on your own terms. Pubs, restaurants and hotels are some of the most obvious places for exhibiting pictures. This has been a long-established custom in France and Italy, and in Britain there is a growing awareness that art can add considerable appeal to a restaurant.

To have your works exhibited in, say, a restaurant, you will first have to approach the owner or manager. More and more restaurants have works for sale on their walls, although you will undoubtedly have to pay a percentage of money from sales to the owner. People often feel generous after a good meal, so as long as it is made quite clear that the works are for sale, you should do some business.

Shops and department stores can also provide potential exhibition space, perhaps to brighten up certain showrooms. Some stores may even be prepared to give you a complete exhibition – Heal's and Liberty in London, for example, have exhibition galleries. There are of course shops that sell paintings and prints, and these may take some of your works to add to their stock. Then there are furniture shops and interior decorators whom you may be able to persuade to hang examples of your work around their showrooms. Always emphasize to the owner/manager that this is a business proposition, and you are not asking for any favours.

It is probably best to look on exercises of this kind more as a form of advertising than of selling, with sales being an additional bonus. You are not going to be around to deliver any sales patter, and you cannot expect staff to persuade customers to buy your paintings. However, the more people who see your name and work, the more likely it is that you will eventually be able to sell it on a grander scale.

It is therefore even worth exploring the possibility of exhibiting in shop windows, perhaps those of building societies or estate agents or of other organizations who wish to draw people's attention to their displays.

Other Sales Opportunities

Markets, fairs and other traditional events which punctuate the calendar of most English towns offer more opportunities to the artist for direct selling. Some of these may be specialized events. The Chelsea Flower Show, for example, rents stalls (not cheaply), some of which are taken by artists, especially flower painters. There are other opportunities in shows where your particular interests may coincide with the theme of the event.

In some towns and cities there are specific open-air areas where paintings are offered for sale from, for example, park railings or shopping arcades; or they

may even be painted and sold on the spot. You must check, however, that you are acting within the law and that you will not fall foul of the public authorities.

Another option is to secure a temporarily unoccupied shop or other property that is perhaps in a transitional phase between owners, or that is waiting to be demolished. Sometimes these can be acquired rent-free, or at a peppercorn rent, although you will of course have to pay for heating, lighting and decoration; and security can be a problem.

Probably the best way to tackle such an enterprise is by forming a group of like-minded artists who have the time to spare to get it off the ground. However, to add a cautionary note, schemes of this kind may sometimes be more aggravation than they are worth. You will need to establish the potential of any such initiative and ensure that you do not end up paying out more than you gain from sales.

Useful Organizations

It is always useful to belong to a group or organization, whether it be the Royal Academy or your local art society. You make useful contacts, extend the possibility of getting your work exhibited, and you get yourself known by a wider circle of people.

You may also enjoy specific financial advantages, such as additional discounts on materials; and from some organizations you may receive direct help with sales, advice or studio accommodation. Some of the best known of these bodies are given below.

Acme Housing Association. 15 Robinson Road, London E2. Tel. 01 981 6811.
A non-profit-making organization set up to help artists, especially in the East End of London, to find accommodation. It has access to some 300 properties, but once you are accepted as a member there is likely to be a waiting period.

Artists' Agency. Sunderland Arts Centre, 17 Grange Terrace, Stockton Road, Sunderland.
An organization which operates mainly in the north east for placing artists in industrial and institutional organizations.

Artists' Placement Group. Riverside Studios, Crisp Road, London W6. Tel. 01 741 2251.
Arranges projects that allow artists to work within commercial, industrial or institutional contexts.

The Artists' Union. 9 Poland Street, London W1. Tel. 01 437 1984.
Open to all professional artists to promote their interests.

Association of Illustrators. 1 Colville Place, London W1. Tel. 01 636 4100.
To promote the work of illustrators and develop contacts with agents and clients. Gallery space available for hire.

British American Arts Association. 49 Wellington Street, London WC2. Tel. 01 379 7755.
An information and clearing centre for exchange between Britain and the USA in all the arts fields, including exhibitions.

The Corporate Arts. 104 York Street, London W1. Tel. 01 402 8024.

An organization to help artists exhibit work in business offices, etc.

Federation of British Artists. Contact the Secretary General, 17 Carlton House Terrace, London SW1. Tel. 01 930 6844.
An umbrella organization which leases the Mall Galleries and includes the following societies: Industrial Painters Group; National Society of Painters, Sculptors and Printmakers; New English Art Club; Royal Institute of Oil Painters; Royal Insitute of Painters in Watercolour; Royal Society of British Artists; Royal Society of Marine Artists; Royal Society of Miniature Painters; Royal Society of Painters, Etchers and Engravers; Royal Society of Portrait Painters; Senefeld Group of Lithographers; Society of Architect Artists; Society of Mural Painters; Society of Women Artists; United Society of Artists. Qualifications for entry to these societies vary, but they all hold annual exhibitions (some open to non-members).

Fine Art Trade Guild. 192 Ebury Street, London SW1. Tel. 01 730 3220.
A professional association for those who trade in fine art.

Institute of Contemporary Arts. ICA, The Mall, London W1. Tel. 01 930 0493.
A centre which encourages contemporary art in all its forms. Arranges exhibitions, and provides a lively social centre, with eating and drinking facilities as well as bookstalls, etc.

National Society for Art Education. 7a High Street, Corsham, Wiltshire. Tel. 0249 741825.
A professional association for those involved in the teaching of art and craft at all levels. Publishes *Journal of Art and Design Education.*

Printmakers' Council. 31 Clerkenwell Close, London EC1. Tel. 01 250 1927.
An open association which promotes the activities of printmakers. It holds exhibitions and maintains contacts between its 500 members.

Royal Birmingham Society of Artists. Hon. Secretary, 69a New Street, Birmingham B2 4DU. Tel. 021 643 3768.
The Society functions as a sort of Midlands Royal Academy which elects members and associates. It holds two annual exhibitions, one open to all, the other confined to members and associates, and has its own rooms and galleries.

Royal Scottish Society of Painters in Watercolour. The Secretary, 17 Sanyford Place, Glasgow 3.
An institution analogous to the English organization with a similar name.

Royal Society of Arts. The Secretary, John Adam Street, Adelphi, London WC2. Tel. 01 839 2366.
Founded in 1754 for the encouragement of art, literature and commerce, the RSA organizes lectures, gives prizes, and plays an important role in the world of art and industry. Exhibitions can be organized on the premises, and membership, which is not difficult to obtain, allows you to put FRSA after your name.

Royal Society of Painters in Watercolour. Bankside Gallery, 48 Hopton Street, London SE1. Tel. 01 928 7521.

A competitor to the Royal Institute, similar in aims and activities, with an annual exhibition.

Shape. 9 Fitzroy Square, London W1. Tel. 01 388 9622.
An organization for effecting contact between artists (in all media) and public organizations such as hospitals, prisons and youth centres, as well as groups dealing with the elderly, the mentally disturbed and the physically handicapped. There are also local equivalents, such as Southern Artlink for the Southern Arts region.

Society of Wildlife Artists. The Secretary, Mall Galleries, 17 Carlton House Terrace, London SW1. Tel. 01 930 6884.
Formed to promote and encourage the art of wildlife painting and sculpture. Open annual exhibition.

Space Studios. 6-8 Rosebery Avenue, London EC1. Tel. 01 379 7755.
Set up twenty years ago to help artists find studios.

GETTING KNOWN

If you are going to make a living, or even part of a living, out of art, you must become known. This is not to say you must achieve fame – that comes after success – but as many people as possible must have heard of you, or have seen your name printed somewhere. Those on whom you will rely for your livelihood – customers, gallery owners, public bodies – need reassurance that you have some standing, as well as talent. Achieving this end calls for more than just good public relations. You must endeavour to sell both yourself and your product, to such a degree that the two become almost inseparable.

It is a process which involves a state of mind as well as a technique. It demands a lot of hard work, sometimes a lack of modesty, a refusal to be rebuffed or admit defeat, an unremitting attention to newspapers and magazines, a constant resolve to retain and exploit every contact you make, and persistent energy in attending as many events as possible (especially private views and other cultural events).

Public Relations

There will be occasions, that of a one-person exhibition, for instance, when an artist will need all that is implied by the phrase 'public relations'.

When this concerns a commercial gallery, in most cases a great deal of the publicity will be handled by the gallery itself. This involves a number of practices with which the owner will be familiar: for example, ringing up critics, having people round to lunch or drinks, using personal contacts, and booking advertising space in magazines – if advertising space is bought, the chances often become that much greater of having editorial space allocated to reviews of your exhibition and illustrations of your work.

But such publicity techniques are not always practised by the owners of smaller galleries, and there are many circumstances in which an artist cannot rely on professional advice, especially if the exhibition has been organized on a private basis.

Critics

At some point, a successful publicity campaign – perhaps culminating with a review in a national newspaper or magazine – will involve an art critic. It is, of course, a good idea to have an art critic on your side; but although they are not venal, art critics are often moved by whim, coincidence, personal knowledge of the artist, or some other strictly non-aesthetic motive.

It is as well to realize that in an average week an art critic probably receives about twenty hand-outs and press releases about forthcoming exhibitions, and invitations to about ten private views. In the course of a year a British critic may visit

countless exhibitions, at venues ranging from the Royal Academy to a new suburban gallery.

He or she will view around 90,000 paintings, about two-thirds of which are by contemporary artists; about 25,000 prints and drawings; and some 2,000 pieces of sculpture. Most of the galleries will be in London or another major city; and in London most of the major ones are within the area bounded by Pall Mall, Oxford Street, Regent Street and Park Lane.

Clearly, if you are having a one-man exhibition at Middlesbrough Polytechnic, distinguished in its own field though that institution is, the likelihood of the art critics of *The Times*, the *Independent* and the *Guardian* coming to the North East just to view your work are at best minimal. But no harm is ever done by writing to a critic, giving details about your exhibition and anything else that may be of interest (although it is best not to try and contact critics by telephone – naturally they hate it).

A Realistic Strategy

Bearing in mind these rather negative provisos about your chances of getting a review of your exhibition into the national daily or weekly press, it is best to devise a realistic strategy for taking advantage of the publicity opportunities that are open to you.

These principally consist of art periodicals, local papers, the arts pages of the national press, and those many journals which occasionally give publicity to art and artists. In addition to these there are local radio and television stations.

It is important to realize that most monthly publications are ready for the printer about a month or six weeks before they actually appear on the bookstalls, and their contents have probably been planned well before that. If you intend to approach them about your exhibition, you should do so at least two months before it opens.

The approach should consist of a personal letter to the editor, explaining your background, any interesting facts about yourself, the nature of your work, etc. It should not exceeed about 400 words in length, should be typed, and written on quality writing paper. As with most commercial things, good presentation can only help your cause.

You should include two or three photographic reproductions of your work. These can be in colour (35mm slides or larger transparencies), or black and white prints. (Colour prints can be reproduced in black and white, though usually with a loss of quality.)

Editors are most unlikely to reproduce any pictures unless they are of good quality, so it is worthwhile arranging to have the photography done professionally. The names of good photographers can be found in the classified advertisements columns of magazines like *Artists' Newsletter*.

Unless it is an integral part of the image, do not include the frame in the picture, as it will inevitably have to be cropped out anyway. Slides (and prints) should always be properly captioned, with an arrow to show which way up and from which side

the image should be viewed. If slides are glass-mounted they must always be packaged very securely for the post. Offer to supply more if required, and enclose a stamped addressed envelope for their safe return.

As an artist you should have a large quantity of photographic reproductions of your work readily available, as this will enable you to use this approach to all magazines which may be interested in your exhibition.

Press Releases

Another general-purpose approach is that of the press release. Journalists and critics often rely on press releases for much of their information, and so they should be pertinent and factual, and sent out well in advance to as many publications as seems appropriate.

Usually press releases are sent out by galleries, but even when this is the case, you should try to have some control over the contents. Gallery owners usually send one out for every exhibition they mount, and they can easily lose their inspirational sparkle.

Once the top copy has been typed, the press release can then be photocopied on a good quality copier and mailed out. Apart from postage, there should not be much expense involved – unless, of course, you wish to send out something more extravagant that requires typesetting and printing.

The following list does not include all the newspapers and periodicals to which you should send publicity material. Al-ways bear in mind publications with which you might have a special relationship: for example, old school magazines; newsletters of organizations; staff journals of the firm you are employed by; and of course, local papers of the area where you live, or perhaps those from where you were born.

· Clearly you should concentrate on those papers which have a specialized art interest, although there are others which, while not having an art critic, are anxious for 'fillers' – paragraphs about events such as exhibitions, usually lifted directly from press releases.

A comprehensive list of UK newspapers and magazines is available in *The Writers and Artists' Yearbook*, published annually by A. & C. Black.

Leading National Papers and their Art Critics

Daily Telegraph, 135 Fleet Street, London EC4P 4BL. Tel. 01 353 4242. Richard Dorment.
Evening Standard, 118-21 Fleet Street, London EC4P 4JT. Brian Sewell.
Financial Times, Bracken House, 10 Cannon Road, London EC4P 4BY. William Packer.
Guardian, 119 Farringdon Road, London EC1. Tel. 01 278 2332. Tim Hilton.
Independent, 40 City Road, London EC1Y 2DP. Tel. 01 235 1222. Andrew Graham Dixon.
Observer, 8 St Andrews Hill, London EC4V 5JA. Tel. 01 236 0202. William Feaver.
The Scotsman, 20 North Bridge,

Edinburgh EH1 1YT. Tel. 031 225 2468. Edward Gage.

The Sunday Times, 1 Pennington Street, London E1 9XN. Tel. 01 481 4100. Lady Marina Vaizey.

The Times, 1 Pennington Street, London E1 9XN. Tel. 01 481 4100. John Russell-Taylor.

Art Magazines and their Editors

Apollo, 22 Davies Street, London W1Y 1LH. Tel. 01 629 3061. Anna Sommers Cocks.

Art Monthly, 36 Great Russell Street, London WC1B 3PP. Tel. 01 580 4168. Peter Townsend.

The Artist, 102 High Street, Tenterden, Kent TN30 6HT. Tel. 05806 3673. Sally Bulgin.

The Artist's and Illustrator's Magazine, The Old Brewery, 6 Blundell Street, London N7 9AH. Tel. 01 609 2222. David Mills.

Artists' Newsletter, PO Box 23, Sunderland SR1 1EJ. Tel. 091 567 3589. David Butler.

Artscribe, 39 North Road, London N7 9DP. Tel. 01 609 2339. Matthew Collins.

Arts Review, 69 Faroe Road, London W14 0EL. Tel. 01 603 7530. Graham Hughes.

Leisure Painter, 102 High Street, Tenterden, Kent TN30 6HT. Tel. 05806 3315. Irene Briers.

Modern Painters, 10 Barley Mow Passage, Chiswick, London W4 4PH. Tel. 01 994 6477. Peter Fuller.

Studio International, Tower House,

Southampton Street, London WC2E 7LS. Tel. 01 379 6005. Michael Spens.

Other Magazines

There are many large circulation magazines which publish regular features about art, and review current exhibitions. Typical of these are:

Art and Design, 42 Leinster Gardens, London W2 3AN. Tel. 01 402 2141.

Country Life, King's Reach Tower, Stamford Street, London SE1 9LS. Tel. 01 261 7058.

Harpers and Queen, 72 Broadwick Street, London W1V 2BP. Tel. 01 439 7144.

House & Garden, Vogue House, Hanover Square, London W1. Tel. 01 499 9080.

Illustrated London News, 20 Upper Ground, London SE1 9PF. Tel. 01 928 6969.

The Listener, 35 Marylebone High Street, London W1M 4AA. Tel. 01 927 4457.

New Society, 42 Lower Marsh, London SE1 7RQ. Tel. 01 620 0255.

New Statesman, 38 Kingsland Road, London E2 8BA. Tel. 01 739 3211.

Time Out, 27 Macklin Street, London WC2. Tel. 01 430 1921.

The Times Educational Supplement, Priory House, St John's Lane, London EC1M 4BX. Tel. 01 253 3000.

Vogue, Vogue House, Hanover House, London W1R 0AD. Tel. 01 499 9080.

Radio and Television

One publicity outlet which many artists tend to forget is radio and television.

There are many arts programmes on local radio stations on which it is possible to get a mention. Television, of course, is more difficult, but that is no reason for not trying. You should watch and listen, and note suitable programmes. There is a lot to be said for proposing a talk by yourself – especially on radio. The addresses of BBC stations of all kinds can be obtained from the telephone directory.

The following list is a selection of independent local radio stations:

Birmingham
BRMB Radio, PO Box 555, Radio House, Aston Road, Birmingham B6 4BX. Tel. 021 359 4481.

Bournemouth
Two Counties Radio, 5-7 Southcote Road, Bournemouth BH1 3LR. Tel. 0202 294881.

Bradford
Pennine Radio, PO Box 235, Pennine House, Foster Square, Bradford BD1 5NP. Tel. 0274 731521.

Brighton
Southern Sound, Radio House, Franklin Road, Portslade, Brighton BN4 2SS. Tel. 0273 422288.

Bristol
GWR, PO Box 963, Watershed, Canon's Road, Bristol BS99 7NN. Tel. 0272 279900.

Bury St Edmunds
Saxon Radio, Long Brackland, Bury St Edmunds, Suffolk IP33 1JY. Tel. 0284 701511.

Coventry
Mercia Sound, Hertford Place, Coventry CV1 3TT. Tel. 0203 28451.

Doncaster
Radio Hallam, PO Box 194, Hartshead, Sheffield S1 1GP. Tel. 0742 71188.

East Kent
Invicta Radio, 15 Station Road, Canterbury CT1 2RB. Tel. 0227 67661.

Exeter & Torbay
Devon Air Radio, The Studio Centre, 35 St David's Hill, Exeter EX4 4DA. Tel. 0392 30703.

Gloucester & Cheltenham
Severn Sound, PO Box 388, Old Talbot House, 67 Southgate Street, Gloucester GL1 1TX. Tel. 0452 423791.

Great Yarmouth & Norwich
Radio Broadland, St George's Plain, Norwich NR3 1DD. Tel. 0603 630621.

Guildford
County Sound, The Friary, Guildford, Surrey GU1 4YX. Tel. 0483 505566.

Hereford & Worcester
Radio Wyvern, 6 Barbourne Terrace, Worcester WR1 3JM. Tel. 0905 612212.

Humberside
Viking Radio, Commercial Road, Hull HU1 2SA. Tel. 0482 25141.

Ipswich
Radio Orwell, Electric House, Lloyds Avenue, Ipswich IP1 3HZ. Tel. 0473 216971.

Leeds
Radio Aire, PO Box 362, Leeds LS3 1LR. Tel. 0532 452299.

Leicester
Leicester Sound, Granville House,

Granville Road, Leicester LE1 7RW.
Tel. 0533 551616.

Liverpool
Radio City, PO Box 194, 10 Stanley Street,
Liverpool L69 1LD. Tel. 051 227 5100.

London
Capital Radio (General and Entertainment), Euston Tower, London NW1 3DR.
Tel. 01 388 1288.
London Broadcasting Company (LBC),
Gough Square, London EC4P 4LP.
Tel. 01 353 1010.

Luton & Bedford
Chiltern Radio, Chilton Road, Dunstable,
Bedfordshire LT1 1HQ. Tel. 0582 666001.

Maidstone & Medway
Invicta Radio, 37 Earl Street, Maidstone
ME14 1PS. Tel. 0622 679061.

Manchester
Piccadilly Radio, 127-131 The Piazza,
Piccadilly Plaza, Manchester M14 1AW.
Tel. 061 236 9913.

Nottingham
Radio Trent, 29 Castle Gate, Nottingham
NG1 7AP. Tel. 0602 581731.

Peterborough
Hereward Radio, PO Box 225, 114 Bridge
Street, Peterborough PE1 1JX.
Tel. 0733 46225.

Plymouth
Plymouth Sound, Earl's Acre, Alma Road,
Plymouth PL3 4HX. Tel. 0752 27272.

Portsmouth
Ocean Sound, Whittle Avenue,
Segensworth West, Fareham, Hants
PO15 5PA. Tel. 0849 589911.

Preston & Blackpool
Red Rose Radio, PO Box 331, St Paul's
Square, Preston, Lancs PR1 1YE.
Tel. 0772 556301.

Reading
Radio 210, Thames Valley, PO Box 210,
Reading RG3 5RZ. Tel. 0734 413131.

Reigate & Crawley
Radio Mercury, Broadfield House,
Brighton Road, Crawley RH11 9TT.
Tel. 0293 519161.

Sheffield & Rotherham
Radio Hallam, PO Box 194, Hartshead,
Sheffield S1 1GP. Tel. 0742 71188.

Southend & Chelmsford
Essex Radio, Radio House, Cliftown Road,
Southend, Essex SS1 1SX.
Tel. 0702 333711.

Stoke-on-Trent
Signal Radio, Studio 257, 67 Stoke Road,
Stoke-on-Trent, Staffordshire.
Tel. 0782 417111.

Swindon
GWR Radio, Old Lime Kiln, High Street,
Wootton Bassett, Swindon SN4 7EX.
Tel. 0793 853222.

Teeside
Radio Tees, 74 Dovecote Street, Stockton-
on-Tees TS18 1HB. Tel. 0642 615111.

Wolverhampton & Black Country
Beacon Radio, PO Box 303, 227 Tettenhall
Street, Wolverhampton WV6 0DQ.
Tel. 0902 757211.

Producing Publicity Material

From the promotional angle, the next most important thing about an exhibition is the invitation card. This should contain as much information as possible, and the most effective way of achieving this is to divide the front of the card into two sections: the right-hand one for the name of the person to whom it is being sent, the left half for the basic information – name of the gallery, opening times, dates of exhibition, title, name of artist. This leaves the whole of the back of the card for promotional messages.

Alternatively, although this can be expensive, you can feature a colour or black and white reproduction of one of your works, or a picture of yourself. Send the invitation cards to hotels, libraries, public museums, public houses, art galleries, shops which sell anything connected with art, local tourist offices – indeed anywhere they are likely to be seen by interested parties.

The cost of printing invitation cards can vary, so shop around for the cheapest printer, and keep your eyes on the classified columns of art magazines. A colour reproduction will cost a fair bit more than black and white, and you may find that the cost of printing 500 cards is not proportionately a great deal more than printing fifty.

Private Views

Private views are an essential part of the selling process, they are much appreciated by a lot of people, and they also have publicity value. If you are working with a gallery, it will probably handle this side of things, asking you to provide your own list of invitees to add to its own.

If there are not going to be special glossy invitation cards for the private view (and they are not absolutely necessary), it is a good idea to send out the general invitations with a letter, card or leaflet giving the details of the private view, and expressing a hope that the recipient will be able to come. On the whole, you could find that about a third of those you invite – and don't forget they will usually bring a companion – will turn up. Outside London, where such occasions are not so frequent, the figure may be a little higher.

The private view scene is, unfortunately, home to a number of freeloaders who are not attached to particular periodicals, but turn up for the food and drink and a good chat. This is an irritating, but unavoidable, facet of the art scene, and it is best not to get too worked up about it.

Though holding an exhibition is a highlight in an artist's career, it is not the be-all and end-all of selling yourself to the public. Seize every possible opportunity to make yourself known. Give serious consideration to submitting articles to art magazines, though make sure that what you are sending them fits in with their requirements. You would not, for instance, send a piece on 'New Ways of Stretching Canvas' to *Art Monthly*, which specializes in contemporary art and artists, so always do your homework first.

If there is a controversial art subject in the news, write to a newspaper about it, always letting it be known that you are an

artist. If you have any talent at all for public speaking, offer to give talks or lectures. Write to poster and postcard manufacturers who might be persuaded to reproduce your works – posters are seen by many more people than invitation cards.

Remember that, unless you are a true genius, it is virtually impossible to be a success as an artist if you hide your light under a bushel – and promotion and publicity are fundamental to the achievement of this success.

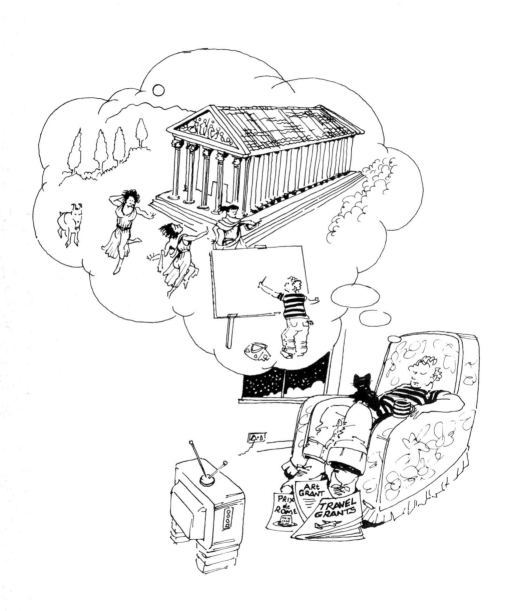

SOURCES OF FUNDING

Few people realize that in Britain every year, several millions of pounds are given to artists. Some of it comes from private organizations and trusts, some from commercial sponsors, but most of it comes from public bodies. It can take many different forms: major prizes such as the Turner Award, or the John Player Portrait Award; fellowships at polytechnics and universities, where 'artists in residence' are given one or two years' support for working on the campus; similar schemes run by local authorities in which the artist works 'in the community'; or awards such as those given by organizations, such as the Churchill Fellowships.

But by far the richest source of support is that provided by the state. Once again this can take many forms. You can obtain grants to attend art schools, to go on painting courses, or if you teach art you can apply for a 'sabbatical' term or year, though in doing so you must be very precise about what you want it for – usually to finish some specific project (doing a series of views of English cathedrals, or recording life in urban areas, or whatever).

The main provider of money for artists is the Arts Council and the various regional organizations which it supports. From this source there are available funds for a wide range of purposes: for the cost of mounting an exhibition; for studio conversions; for interest-free loans for some specific purpose, such as casting sculpture; for framing; for travel; for the purchase of materials in the early years of professional work; for creating art – murals or sculpture – in public places; and so on. In addition both the Arts Council and the British Council purchase works of art for their own collections, usually through dealers, or from works in a mixed exhibition.

Applying for a Grant

How should one tap this source of patronage? First of all, decide from the information given on the following pages what kind of grant you want to apply for. Then telephone the relevant institution, stating that you wish to apply for such and such a grant, and ask what is the procedure. Find out the name of the person to whom you should address your application. Sometimes there will be a specific application form, sometimes not. In either case it is essential that your application should be as specific and factual as possible. Give full details of your training; enclose slides, transparencies or prints of your work; state where your works have been exhibited; send any press cuttings you may have. And give precise details, with figures if possible, of how you propose to spend the grant. Do not expatiate on your ideas about art, or politics, or the state of society. If you don't have a typewriter, pay

to have the application typed.

Decisions are usually made by a committee composed of people such as artists, administrators, critics and the like, and chaired by officials, who naturally tend to have a determining role. It is therefore important that you should mix as much as possible in the art community, going to galleries – private views if possible, joining the Friends of the local art gallery, or some similar organization, and generally trying to get yourself known. On the whole it must be said that your chances of getting support from bodies such as the Arts Council are not very good if you are a strongly traditionalist painter or sculptor, though of course a good deal depends on the composition of the selection committee – they usually change every three years – and indeed on the subtle changes in taste which are always taking place. During the past few years, for instance, figurative artists have, on the whole, been looked on much more favourably than they were before, when only the most abstract or the most explorative art styles were in official favour.

Regional Arts Associations

The policies of the Arts Council and the Regional Arts Associations change from time to time, though for typical application regulations see below under Greater London Arts, and see also the relevant sections in other chapters on the legal and VAT implications of grants.

1. ARTS COUNCIL OF GREAT BRITAIN
Covers: the arts in England.
105 Piccadilly, London W1V OAU.
Tel. 01 629 9495

(a) Purchase of Works of Art
Paintings, sculptures, photographs and drawings by British artists and prints by British and foreign artists are bought for inclusion in touring exhibitions and for long-term loan to museums, galleries and other public buildings. Applications supported by slides from artists living in England are considered at any time of the year.

(b) Exhibition Subsidy
Applications can be considered from organizations and individuals, for grant-aid for exhibitions and one-off events involving the public presentation of art. Normally grants do not exceed 50 per cent of the net cost of the exhibition. The deadline for applications is 31 January, for a subsidy in the following year.

(c) Special Art Projects
The Arts Council will consider applications for financial support from individuals or organizations for projects or events which contribute to national awareness of contemporary art and encourage patronage. Proposals may include publications or one-off events not covered by schemes administered by the RAA. Deadlines are August and November.

(d) Fellowships
Applications are invited from potential host organizations, to enable them to

provide 'time-off' fellowships whereby artists can reside and work in locations sympathetic to their work for at least a year. Grant aid is usually no more than 50 per cent of the total cost of the fellowship, including a stipend for appropriate studio facilities, accommodation, board, and an exhibition of the artists' work. Deadlines in August and November.

(e) Studio Conversions
Applications can be considered for capital grants towards the cost of converting premises serving as communal studios for properly-constituted groups of at least ten artists. Applications for studios in London should be addressed to the Greater London Arts Association. Usually, grants will only be given towards the cost of provision of basic partitioning, electrical and plumbing services, though essential items of equipment may be included. In assessing applications, consideration is given to the number of artists accommodated in relation to the estimated cost, the length of the lease (minimum five years), the suitability of the premises, and the rent, rates and other outgoings.

(f) Thornton Bequest
Application may be considered from artists for loans towards the costs of casting sculpture. Loans are interest-free and are repayable on the sale of the pieces cast. This is a small bequest, and the main deadline for the year's application is August.

(g) Training Schemes
Individual training bursaries are available to fine artists, photographers, etc. Arts organizations can apply for funds for short courses, workshops, etc. Training for artists and arts organizations to enable involvement in education work (including residencies, workshops, etc.) may be funded.

2. ARTS COUNCIL OF NORTHERN IRELAND
181a Stanmillis Road, Belfast BT9 5DU.
Tel. 0232 663591

(a) Major Awards
There are three major awards of £5,000 each, that are intended to enable the recipients to concentrate on their work for a lengthy period, and are open to creative artists only. Applicants must be able to ensure that they will be following their particular discipline 'full-time' for six to twelve months.

(b) Fellowship
A one-year fellowship in printmaking is available at the Arts Council's print workshop in Belfast.

(c) Bass Ireland Awards
To encourage the enrichment of the cultural scene by providing financial assistance to all aspiring, creative individuals or groups in all branches of the arts.

(d) PSI Fellowship
The International Studio Programme provides studios in New York, and two artists from Ireland are funded by the Arts Council in Ireland and Ireland American Arts Exchange. The fellowship conditions are as for the Bursary. May deadline.

(e) Bursaries

Bursaries are awarded to creative and performing artists active in any field of the arts and to those engaged in the direction and presentation of artistic events. Awards are made on the potential good to both the individual applicant and the artistic development and welfare of the whole community. They are open to artists born and living in Northern Ireland; to those born in Northern Ireland but living elsewhere and contributing regularly to the community's artistic activities; or to those who have been living in Northern Ireland for at least three years.

Alice Berger Hammerschlag Award

The award is open to visual artists (including theatre designers) living in either Northern Ireland or the Republic of Ireland. Application forms available from the Awards Secretary, Arts Council of Northern Ireland.

3. SCOTTISH ARTS COUNCIL
Covers: Visual Arts and Photography in Scotland.
19 Charlotte Square, Edinburgh EH2 4OF.
Tel. 031 226 6051

(a) Awards

Awards are offered towards the cost of specific major products. They can be used to cover the costs of materials, services, travel and subsistence, and in certain cases to prepare or mount exhibitions. Exhibition costs will normally cover materials and framing, but transport, publicity, etc. can be considered when the exhibition is held at a gallery not subsidized by the Scottish Arts Council.

Awards cannot be used for the purchase of equipment (such as cameras, printing presses, etc.). 1 April/1 September deadlines.

(b) Small Assistance Grants

Grants are awarded to assist a large number of professional artists with the smaller, more immediate costs involved in practising their art. Applications for a variety of projects will be considered, which might include materials for new experiments, framing for exhibitions, studio conversion costs or new initiatives. Applications throughout the year.

(c) Bursaries

These are considered to be prestigious awards, intended for established artists of professional standing. They can be used to 'buy time', i.e. release an artist from other commitments to concentrate on his/her art or for travel for artistic purposes. They will be used for detailed projects which require extensive forward planning. September deadline.

(d) Young Artists' Bursaries

These are intended for artists under thirty years of age, to encourage the development of their work. Applicants must be able to demonstrate a commitment to achieving a career as an artist and must be able to identify how they would see their work developing. Young artists' bursaries can be used to supplement the artist's income and enable him/her to devote more time and energy to art. September deadline.

(e) Travel Grants

To enable artists to attend one-off con-

ferences, study courses and, in special cases, exhibitions outside Scotland. This scheme serves principally to assist those who wish to gain experience relating to, or derive some benefit from, their professional work but who have not specifically been invited to show their work by a foreign country. Exhibitions here refer to unusually important historical or contemporary exhibitions which are essential to the applicant's area of work. SAC can contribute up to 50 per cent of the total costs. Applications throughout the year.

4. WELSH ARTS COUNCIL
Covers: Wales.
Museum Place, Cardiff CF1 3NX.
Tel. 0222 394711

(a) Interest-Free Loan
Loans are interest-free and repayable over a period of up to three years, and will be offered for any purpose to do with the professional practice of art. They are particularly intended to help with costs such as converting a studio, editioning a set of prints, buying materials or equipment, or preparing work for exhibition. Loans may be applied for at any time throughout the year. Applications for loans are dealt with on first-come, first-served basis, and will be offered as long as the artist satisfies the basic requirements of the scheme.

(b) Setting-Up Grants
Grants are offered to help with the cost of setting up a first studio, purchasing materials in the early years of professional practice and preparing a first exhibition. Each applicant must be over twenty years of age and at the start of his or her career

as an artist. It is a new condition from 1987 that artists may receive only one Setting Up Grant (formerly known as Young Artists' Grants) in their career. There are many more applications than there is money available and therefore selection is likely to be stringent. January, May and October deadlines.

(c) Masterclass and Industrial Experience Grants
Masterclass grants are given to enable artists to study with a 'master' whose work they admire or from whom they may learn an unfamiliar skill or technique. Industrial experience grants offer artists the chance to spend time in the factory, foundry or other organization in order to gain experience in using particular materials or manufacturing processes. May and October deadlines.

(d) Travel Grants
Grants are offered to enable artists to spend periods doing individual research or work away from their usual domicile: visiting another place because of the art it has inspired in the past, or the art being made there at the moment, or because of the art that is there in museums and galleries; or studying a particular landscape, history or culture. May and October deadlines.

Arts Associations

5. BUCKINGHAMSHIRE ARTS ASSOCIATION
This autonomous county-based arts association covers Buckinghamshire and is a client of East Midland Arts.

55 High Street, Aylesbury,
Buckinghamshire HP20 1SA.
Tel. 0296 34704

(a) Purchases Scheme

Non-profit-distributing organizations in the county wishing to purchase contemporary works for public places may apply for support under the scheme. Up to 50 per cent of the purchase price may be available. Buckinghamshire artists are invited to contact organizations which qualify for support under this scheme with a view to encouraging an application and sale.

(b) Starter Grants

Artists who have completed their studies or otherwise begun professional practice in the past three years are eligible to apply for the Starter Grant. This is a simple award not tied to any specific requirements of purchase or project. It is intended to support those artists who have, in the association's view, the potential to become of country-wide significance. Only artists living and/or working in Buckinghamshire will be considered.

(c) Project Grant

Visual artists, craftspeople and photographers who wish to undertake a project which may, for instance, involve any activity which will increase or extend the applicant's experience and/or range of work (but will not include the participation in further or specialized training courses) can apply for a project grant. The applicant will also be expected to make a financial contribution.

(d) Exhibition Grant

Any artist invited to exhibit in an approved gallery within the county may apply for an Exhibition Grant, which is mandatory for exhibitions in the County Museum, Aylesbury, and the Exhibition Gallery, Milton Keynes, and discretionary in others. Other galleries and exhibition spaces will be approved if they are deemed suitable for the display of visual arts and/or crafts materials, if they can guarantee substantial public access to the exhibition over a minimum period of two weeks, and if adequate publicity and marketing of the exhibition will be carried out. Only artists living and/or working in Buckinghamshire will be considered for an award.

(e) Group Exhibition Grant

Any group or association of artists invited to exhibit at or organizing an exhibition in an approved gallery may apply for a Group exhibition grant. The conditions and definitions are the same as above.

(f) Residency Grant

The association encourages short- and long-term residencies within a variety of organizations (factories, hospitals, schools, colleges, etc.) throughout the country. Residencies should be developed in close consultation with the association's staff and advisers. A Residency Grant of up to 50 per cent of the costs of an exhibition may be available in some circumstances.

(g) Venue Grant

A Venue Grant may be available for those venues wishing to organize an exhibition of contemporary visual arts, crafts or

photography. While open to the approved galleries, the association wishes to encourage non-gallery spaces to participate and they will be given priority under this scheme. Up to 50 per cent of the costs of the exhibition may be applied for.

(h) Setting-Up Grant
A non-gallery venue wishing to create an exhibition space that will be used regularly may be eligible for a Setting-Up Grant towards the cost of hanging facilities and lighting.

(i) Education Grant
The association would like to encourage workshops, seminars and other education-related activities in the visual arts, crafts and photography. Organizations (such as artists' groups, hospitals, galleries, colleges, schools and community centres) may apply for an Education Grant. This can contribute up to 50 per cent of the fees, paid to artists who are exhibiting at approved galleries taking part in this scheme.

6. EAST MIDLANDS ARTS
Covers: Leicestershire, Northamptonshire, Nottinghamshire and parts of Derbyshire.
Mountfield House, Forest Road, Loughborough, LE11 3HU.
Tel. 0509 218292

(a) Starter Grant
This is intended to help with basic costs such as materials, working time, etc. To qualify, artists are normally expected to have completed their full time (art) education, no less than six months prior to the date of application. Other artists beginning their careers will be eligible for a starter grant at EMA's discretion.

(b) Project Grant
Awarded to artists who have been working professionally for more than three years. However, sympathetic consideration will be given to any project or proposal for the development of an artist's work. Assistance cannot be offered towards the cost of alterations to studio accommodation where the artist works from home.

(c) Purchase Grant
The association will consider matching 50% of the costs of purchasing a work for either a public or semi-public site or a public collection in the region. While applications have to come from the organization, artists can and do initiate such purchases. It is essential that the artists who wish to participate join the Art Index.

(d) Payments to Artists for Exhibiting
This is a discretionary scheme whereby exhibitors at recognized galleries in the region may be eligible for payments. Exhibitors should ascertain from the galleries themselves whether or not they participate in this scheme. If in doubt contact the Visual Arts Officer.

(e) Residencies/Placements
East Midlands Arts has developed a number of short- and long-term residencies in schools, colleges and hospitals. Those which run for six months or a year are advertised nationally. Schools placements are selected by the institution in consultation with advisory staff and the

association. EMA does not currently run schemes which place artists in industrial or commercial settings.

(f) Artists at Work
This scheme supports placements and workshops in the community and in education using professional artists, architects, craftspeople and photographers. Venues pay half the costs of the fee and expenses related to the lecture, workshop or placement, and EMA will pay the other half. EMA prefers applicants to use regionally based artists, but support for other artists will be considered. There are no minimum requirements for the scheme – applications can be made for a single lecture or a ten-day placement. Placements of longer than fifteen days are ineligible. Applications must be received at least six weeks before the event.

7. EASTERN ARTS
Covers: Essex, Suffolk, Bedfordshire, Hertfordshire, Cambridgeshire.
8/9 Bridge Street, Cambridge CB2 1UA.
Tel. 0223 357596

(a) Support for Visual Artists
To support practising artists in its region is one of Eastern Arts foremost concerns. The grant aid, schemes and projects reflect a fundamental commitment to achieving more patronage and opportunities to visual artists. Schemes offering grant aid or awards to individual artists are no longer directly run by EA. Instead, funding is being channelled through galleries to reinforce their role in supporting artists in various ways. The devolved support scheme is flexible and currently in

process of evolution. To date, funding has been devoted to exhibition bursaries, artists' forums, professional training and advice sessions. The support scheme is run through the following centres:

Bedfordshire and Hertfordshire. Luton Community Arts Trust, 33 Guildford Street, Luton, Bedfordshire. Tel. 0582 419584.
Cambridgeshire. Visual Arts Panel, Peterborough Arts Council, Priestgate House, 3-7 Priestgate, Peterborough PE1 1RW. Contact the Chairman, Tel. 0733 311466.
Essex and Suffolk. The Minories, 74 High Street, Colchester CO1 1UE. Contact the Director, Tel. 0206 577067.
Norfolk. Norwich School of Art Gallery, St George Street, Norwich NR3 1BB. Contact the Curator, Tel. 0603 610561.

(b) Payment to Artists for Exhibiting Work
The scheme applies to exhibitions held in public galleries (private or commercial galleries are excluded). The gallery must be large enough to accommodate a substantial show. Payment is made only in respect of one-person or two-person exhibitions. If an exhibition tours, there is a fee for each additional showing. As it is, the scheme's purpose is to provide a fee in recompense for public access to an artist's work. The payment should be regarded as over and above the gallery's normal expenditure on mounting the exhibition. EA encourages galleries to make use of a written contract or agreement to regulate exhibition arrangements.

Since funds available are limited, it is not possible to guarantee that payments

can be made automatically to all artists eligible to receive them. The following galleries can participate:

Bury St Edmunds Art Gallery.
Cambridge: Cambridge Darkroom, Fitzwilliam Museum; Kettle's Yard Gallery.
Chelmsford and Essex Museum.
Colchester, The Minories.
Great Yarmouth: Great Yarmouth Exhibition Galleries (Norfolk Museums Service); Playhouse Gallery.
Hertfordshire College of Art and Design.
Hitchin Museum and Art Gallery (North Hertfordshire Museums Service).
Ipswich: Ipswich Museums (Christchurch Mansion); Fermoy Gallery.
Letchworth Museum and Art Gallery (North Hertfordshire Museum Service).
Lowestoft Art Centre.
Luton Museum and Art Gallery.
Norwich: Castle Museum (Norfolk Museums Service); Sainsbury Centre for Visual Arts; Norwich School of Art Gallery; Library Concourse, University of East Anglia.
Peterborough: City Museum and Art Gallery; Beecroft Art Gallery.
Stevenage: Leisure Centre; Gainsborough's House; Wells Centre.
 This scheme is currently under review.

(c) Artists in the Community

This scheme is an expansion of 'artists in schools', and aims to develop enthusiasm for the visual arts on a wide front through direct contact with artists, craftspeople and photographers by extending access to the visual arts to those not served by galleries, or not inclined to use them. The scheme will be open to any organization or group in the region eligible to receive grant aid from Eastern Arts and capable of ensuring sufficient 'audience' for, or public access to, the artist. It will, as a rule, provide for a minimum of three sessions, and a maximum of ten. A series of visits could involve different artists, but if so, would be coherently planned. In most cases, allowance would have to be made for a preliminary visit (half day) by the artist – who can be within or outside the region. EA provides funding at a standard rate of 75 per cent of the artist's fee. Deadlines: Schools projects have a September deadline for the academic year, other applications are accepted throughout the year.

(d) Art and Craft in Public Places

EA is active in encouraging the purchasing and commissioning of works of art, craft and photography for public sites and collections through the Art in Public Places scheme in conjunction with the Arts Council and the Crafts Council. An essential aspect is the EA advisory service which has specialist staff to advise and assist at all stages. EA can provide grant aid for projects under this scheme of up to a maximum of 50 per cent of the total cost.

8. LINCOLNSHIRE AND HUMBERSIDE ARTS
Covers: Lincolnshire and Humberside
St Hugh's, Newport, Lincoln LN1 3DN.
Tel. 0522 33555

(a) The Payments to Artists Scheme
This scheme offers a discretionary payment to an artist for exhibiting his/her

work in certain galleries in Lincolnshire and Humberside. It is not a payment to defray general exhibition costs. The fee is quite distinct from any payments made to the artist by the gallery, and professional exhibitors should seek support from the gallery for such items as transport, expenses, publicity, and insurance. This fee is also quite separate from any sales, lecture fees, etc. that an artist may earn from his/her exhibition. A fee will be paid to professional artists and photographers. Artists whose work tours in the region will be paid for each additional place of showing, at the discretion of the Visual Arts Consultants. The minimum period of exhibitions is three weeks.

(b) Exhibition Grants

See above. These are to assist individuals to prepare work for exhibition within or outside the region, including exhibitions abroad. Production of the work of art will not receive grant aid, but glazing, framing and transportation will. Craftspeople may also apply for production costs. Applications for publicity and marketing material are encouraged. Applications must be received well in advance as no applicaton can be considered after an exhibition has opened.

(c) Special Grants

Included either in the budget for Exhibition Grants or see below. These allow groups or individuals to apply for financial support towards projects including: training, research, administration, publicity, multi-media events, gallery developments, etc. Individuals, studio groups, societies or organizations wanting to hold the kind of events listed above are eligible to apply. Applications for financial support for studio and workshop initiatives will be assessed taking into consideration the aims and objectives of the group, and the quality of work of those involved. LHA put a high priority on awarding grant aid to studio projects involving professional artists. The public dimension of the studio/workshop will be noted. The project should aim to develop some facility available to the public, such as an exhibition space.

(d) Commissions and Residencies

The commissions scheme covers all aspects of the contemporary visual arts: paintings, prints, photography, sculpture, and the whole field of the crafts. The scheme encompasses a wide range of possibilities, from the commission of works for schools, to buying and commissioning for the enhancement of public buildings, outdoor sites, or for functional purposes within such settings. One of the scheme's objectives is to generate local support and funding for the commission, and therefore LHA generally offers up to 50 per cent of the total cost of a commission. Commissioning is essentially a collaborative activity. LHA offers specialist advice, as well as advice to help intending commissioners through the whole process of commissioning.

The residencies scheme similarly covers all aspects of the contemporary visual arts. An artist in residence is a project which offers the opportunity to work in a particular kind of environment such as a hospital, school, industry, etc.,

for a period of time. Residencies have often been used in the process of commissioning works of art for public spaces. The residency must take place within the region and there must be a selection process to find the artist.

(e) Education/Talks Scheme

This heading covers Artists in Schools sessions from half a day to a term and also any event or programme run by a group or society to hold talks or workshops connected with an exhibition or other relevant schemes. Deadlines for application for all schemes are: 17 February, 20 April, 22 June, 23 August, 25 October.

9. GREATER LONDON ARTS

Covers: the arts in 32 London boroughs and the City of London.
9 White Lion Street, London N1 9PD.
Tel. 01 837 8808

The policy of Greater London Arts is to further the understanding, practice and enjoyment of the visual arts. More specifically, this involves:

● Encouraging the wider dissemination of the image.
● Improving independent art galleries.
● Encouraging the production of 'innovative' work in the public sector through artists' placements, commission or collaboration.
● To improve the professional and economic status of the artists and to improve their influence within the community

Individual Grants

In the furtherance of these individual aims, as stated in the Greater London Arts'

policy documents, the main emphasis is giving help to institutions, groups and the like. But assistance is also available to individuals, and in this context 'particular priority will be given to Black and Asian art'. The GLA considers that the support of individual practice is of primary importance, and to this end grants are offered to artists who are resident in London, who are not at art school, nor have been within the last year, and who have available a representative body of work for assessment by an Advisory Group.

Grants are not available for studio conversions, framing, gallery hire, private view costs, printing and publicity, or the purchase of capital equipment. Grants will not be given retrospectively.

The closing date for applications is in September and October of each year for a grant in the following year, and assessments will take place between two and six weeks after the closing date. To submit an application you must obtain a form from the GLA. No application will be accepted without supporting material, consisting of six 35mm colour slides of recent work which should be packed in a flat transparent envelope.

In addition to these individual grants, the GLA is also involved in:

Commissions

Consideration is given to the commissioning of permanent or semi-permanent works of art in public places, including libraries, hospitals and other institutions. Emphasis is placed on those commissions that are specifically intended for a particular place.

4 SOURCES OF FUNDING

Placements

The GLA gives consideration to proposals that seek to promote the links between the visual arts and the public through the placement of artists by way of residency within the public sector. Placements may be of different duration and can be in schools, hospitals, community centres, museums, art galleries, etc. (one such scheme is in existence at the Imperial War Museum). Funds for this are limited, and the GLA would normally require some financial co-operation from the host organization.

There is no specific deadline for the two categories above, and further details of both can be obtained from the GLA.

10. NORTH WEST ARTS
Covers: Lancashire (except West Lancs.), Cheshire, Greater Manchester and the High Peak District of Derbyshire.
12 Harter Street, Manchester M1 6HY.
Tel. 061 228 3062

The Association is concerned to support both the production and the presentation of the visual arts. This may well be done, not simply through direct grants, but by using limited resources to create an effective information service and co-ordinating role. The entire budget is committed for the year by 2 June.

(a) Payments to Artists for Exhibiting
Allocated to individuals.

(b) Exhibition Support
Allocated to organizations.

(c) Partnerships
Allocated to galleries.

(d) Grants to Organizations
Allocation includes studio groups and the National Artists Association Conference.

(e) Survival Seminars
These are intended as part of a broader package of activity aiming at giving artists access to information on 'marketing' and 'surviving'.

(f) Environmental Art
A budget is available for development of environmental art. Project allocation is largely committed by 1 June.

11. NORTHERN ARTS
Covers: Cumbria, Durham, Northumberland, Cleveland and Tyne & Wear.
10 Osborne Terrace, Newcastle upon Tyne NE2 1NZ.

(a) Visual Arts Awards
Individual awards are made annually. Since it is not realistic to expect Northern Arts to be able to fund an artist's practice the awards are now slanted towards opportunity. The Selection Committee broadly considers three categories of awards with the emphasis laid on a public aspect which could be in the form of an exhibition, purchase or commission.
- Projects. Individual projects of the artist's choosing will be considered for this open category.
- Creating Opportunities. Awards in this category will be concerned with the public manifestation (exhibition, commission etc.) and will attempt to attract additional funds.
- Helping Young Artists. Awards will be

68

made to assist young artists establishing their practice, with assistance being considered for materials, equipment and studios. Deadline for applications: 25 September.

(b) Support for Artists

This allocation covers a wide category of support for artists and for making their work public. It covers residencies, purchasing, commissions, murals, grants for specific projects, studio groups, etc. Schemes using this budget include placements through the Artists' Agency and the Drysdale Forest Sculpture Residency. Commissions and purchases are arranged through the Commission Agent. Various commissions will be offered throughout the year, including Art in the Metro, and work in Gateshead, Durham and Sunderland. This open category is flexible in order to invest monies where the best opportunities occur. Even at the mid-stage of the year the allocated figure is virtually committed and applications by artists will tend to be considered under the Awards scheme.

(c) Northern Arts Bursary

A bursary is offered to an artist living in the region not engaged in full time teaching. It is envisaged that the bursary holder's work will be exhibited in a regional venue at the end of twelve months. Applicants can apply for both an award (above) and the bursary. Deadline for applications: 25 September.

(d) Project Loan Scheme

In 1983 the association established interest-free Project Loans to artists. The funding for the loan comes from the Visual Arts Department Fund which derives its monies not from the Visual Arts budget but from earned income mainly accrued from the commission on and the sales of works of art. Project loans are repayable over two years and are awarded on the basis of the artistic quality of the project and the applicant's ability to repay. Loans are used for buying equipment and materials, studio improvements, preparing work for exhibition, publishing or print editioning, etc. Applications are considered quarterly.

(e) Payments to Artists for Exhibition

Exhibition payment is made for one- or two-artist exhibitions at the major visual art galleries in the Northern Region. This would cover exhibitions at local authority art galleries such as Carlisle and Middlesbrough, educational galleries, as well as Northern Arts funded venues such as the Bede Gallery and the Northern Centre for Contemporary Art.

12. SOUTH EAST ARTS

Covers: East Sussex, Kent and Surrey (excluding Greater London areas).
9-10 Crescent Road, Tunbridge Wells, Kent TN1 2LU.
Tel. 0892 41666

(a) Commissions and Residencies:

Commissions

South East Arts in partnership with the Arts Council and Crafts Council works to encourage local authorities, industry or commerce to commission or purchase work for public sites and considers app-

lications for grants towards the cost of any such commission or purchase of work by artists or craftspeople for any interior or exterior space which may be reasonably defined as a public area. Grants are also available for architects and others wishing to engage, for a period, one or more artists or craftspeople as part of a planning or design team.

Residencies

Each year SEA negotiates directly with appropriate institutions for a number of residential appointments for artists or craftspeople, for which applications will normally be invited by public advertisement or announcement.

(b) Payments to Artists for Exhibiting

SEA participates in a national scheme which seeks to establish as a matter of principle the right of professional artists and photographers (it excludes craftspeople), to be paid in return for making their work available for exhibition in public galleries. The scheme is restricted to discretionary payments in the case of one- or two-person exhibitions only at the following regional galleries which administer the scheme directly:

Brighton: Art Gallery and Museums (including The Grange, Rottingdean); Polytechnic Gallery; Royal Pavilion; Gardner Centre for the Arts, Sussex University.
Canterbury, The Royal Museum.
Eastbourne, Towner Art Gallery.
Farnham: West Surrey College of Art and Design; and Photogallery (for photography exhibitions).
Gillingham, GEAC Gallery.

Hastings Museum and Art Gallery.
Margate Library.
Folkestone, Metropole Arts Centre Trust.
Ramsgate Library.
Rye, Easton Rooms.

It is a condition of inclusion in the scheme that the galleries meet publicity, transport and insurance costs. This scheme is at present under review.

(c) Education/Schools Projects

South East Arts funds either directly, or through its revenue clients up to eight placements in schools a year, whereby professional artists and craftspeople represented on the SEA slide register go into primary or secondary schools for a period (which need not be continuous) of less than two weeks. SEA provides the artists/craftspersons expenses and fee. It is normally a condition of the scheme that the school matches this latter sum in order to purchase or commission a piece of work by the visiting artist/craftsperson which will go on display as a permanent reminder of the visit.

(d) Gallery Subsidy

Open to application from regional (non-revenue funded) galleries for temporary exhibition, education programmes, publishing catalogues or exhibition promotion. February/March deadline.

13. SOUTH WEST ARTS

Covers: Avon, Cornwall, Devon, Dorset (except Bournemouth, Christchurch and Poole), Gloucestershire and Somerset. Bradninch Place, Gandy Street, Exeter EX4 3LS.
Tel. 0392 218188

(a) Awards to Individuals/Fellowships:

Fellowship in Fine Art or Photography

The purpose is to allow an artist or photographer to work in his or her own studio without financial pressure, for a period of three months. It is expected that a worthwhile body of work will be produced with the potential for an exhibition at its conclusion, but this is not a necessary precondition. The successful applicant will be expected to leave any full-time employment during the Fellowship.

Three Project Awards in Fine Art or Photography

The purpose is to allow artists and photographers to put forward specific projects which can be seen to be of direct benefit to their careers. Examples of projects might be: production of a specific self-contained body of work; a series of artworks based on a specific theme; a project with a wide social application, e.g. a mural, a co-operative or collaborative project; travel for the purpose of work; research (must not be pure academic research). One criterion for the allocation of these awards will be whether the work will be seen by the public on its completion (applications for framing, materials, equipment and studio conversion costs will not be considered).

(b) Residencies

Three residencies are run: Sculptor in Residence in the Forest of Dean; Painter in Residence at the Royal Albert Memorial Museum, Exeter (September deadline); and Photographer in Residence at the Royal Photographic Society, Bath (September deadline).

(c) Exhibition Fees

(d) Artists/Craftworkers in Schools

(e) Exhibitions/Projects/Performance

The only discretionary funds available are the allocations for exhibitions and projects, and these are used to respond to applications which come in through the year. As a general rule, these funds are intended to support group or organizational activities, not individuals' work.

Other Organizations

In addition to bodies directly concerned with subsidizing the arts, either on a regional or a national basis, there are a large number of other organizations which can give help of various kinds, ranging from grants and purchases to help in the selling or placement of a work of art, especially if it can be made to have some 'community' relevance. These include:

Air and Space (Art Services Grants Ltd.). 6 & 8 Rosebery Avenue, London EC1. Tel. 01 278 7795.
An organization formed to provide services for artists and to give them free information about setting up and running a studio. The Air Gallery specializes in helping artists who have not had a chance to exhibit in London and who are not commercially represented.

Artists' Agency. 11 Grange Terrace, Stockton Road, Sunderland SR2 7DF. Tel. 0783 41214.
Arranges placements and other opportunities for artists, especially in places

such as hospitals, factories and other institutions. The cost of these is funded by arts bodies such as Regional Arts Associations and by the host organizations.

Artists' General Benevolent Fund.
Burlington House, Piccadilly, London W1. Tel. 01 734 9052.
An organization of long-standing, instituted by artists to provide financial help to members of the profession who are in need of assistance because of illness, misfortune or old age. Widows are eligible, and, in certain circumstances, orphans.

The Artists' League of Great Britain.
Bankside Gallery, Hopton Street, Blackfriars, London SE1. Tel. 01 928 7521.
Founded in 1909 to protect and promote the interests of artists and to advise and assist artist-members in business matters connected with their art.

Artists' Placement Group. Riverside Studios, Crisp Road, London W6. Tel. 01 741 3947.
The aim of the group is to associate artists with organizational structures, emphasizing the relevance of artists working within a particular industrial or commercial context. Artists are placed to work within groups such as British Steel, British Rail, ICI, the Department of the Environment, and the Scottish Office, producing works of art tailored to the needs of the patron.

Artspace, Merseyside. Bridewell Studios, Prescott Street, Liverpool 7. Tel. 051 260 6333.
An organization of professional workshops and studios with both fine art and

craft objectives. The revenue is provided by the rent paid by the artist-tenants.

The British Council. British Council Fine Arts Department, 2 Portland Place, London WC1X 4EJ. Tel. 01 636 6888.
Covers British art abroad. The function of the British Council is to promote British culture abroad. It tours exhibitions of well-known artists such as Howard Hodgkin and Henry Moore. At the same time it gives grants to individual artists to enable them to hold exhibitions of their work abroad, either at mixed shows or at commercial galleries. It also buys works for its own collection, though it usually does this through the galleries which act for artists.

City Gallery Arts Trust. The Great Barn, Parklands, Great Linford, Milton Keynes, MK14 5DZ. Tel. 0908 606791.
Involved with the commissioning of work in Milton Keynes and the East Midlands, including the development of art projects in hospitals, charitable institutions and commercial contexts. It also sets up artist in residence schemes.

Contemporary Art Society. Tate Gallery, 20 John Islip Street, London SW1P 4ll. Tel. 01 821 5323.
Founded to encourage contemporary art and buy examples of it for display in public art galleries and museums. Funded by the subscriptions of members, each year one member is allotted a sum of money to buy works of modern art of his or her own choice. The Society also invites business firms to become corporate members, and in return offers them advice in buying contemporary art or on sponsorship of the

arts. It has helped to create substantial collections of modern art for De Beers, BP, National Westminster Bank and Unilever.

Federation of British Artists. 17 Carlton House Terrace, London SW1.
Tel. 01 930 6844.
A registered charity under which a group of older 'Royal' societies and others specializing in some theme or medium (e.g. pastel or marine) operates. Anyone may submit work to any of these societies' open exhibitions, some of which offer prizes.

Gulbenkian Trust. 98 Portland Place, London W1N 4ET. Tel. 01 636 5313.
Gives grants for specific purposes, usually of community interest. Support is also given to a variety of public art and artists' placement projects which supply hitherto neglected needs in the arts.

International Association of Art.
31 Clerkenwell Close, London EC1X 4ST.
Tel. 01 250 1927.
Founded under the auspices of UNESCO, to represent artists specializing in the visual arts in sixty-four countries. Members are provided with a card which gives reduced or free admission to many museums and art galleries. Most importantly too, it makes available a travel document which helps artists taking their works through customs to secure their rights under the Brussels and Florence Conventions. The Central Office maintains an information service for members regarding travel fellowships, exchange of studios, etc. Conferences are held regularly in different parts of the world.

Public Art Development Trust.
6 & 8 Rosebery Avenue, London EC1 4TD.
Tel. 01 837 6070.
Encourages architects, local authorities and other bodies from the public and private sectors to commission artists to provide appropriate works for various undertakings, and to encourage co-operation between artists and architects in new building and landscape schemes.

Residencies and Fellowships

The notion of having, as it were, a tame artist to come and work (and sometimes live) in a specific environment to spread an awareness of the validity of living art is a comparatively new one, though it has spread very rapidly. It was originally started by the academic world, and has spread to public art galleries, industrial and community institutions.

Being a resident artist can provide a stipend, a place to work and exhibit, publicity, an audience, and often sales. Most of them are administered by Regional Arts Associations, but some are not, and it is important to keep a watchful eye open. Many of the decision-makers are open to a good suggestion. Your RAA will provide you with a list of such residencies available in your area, but the following will give you some idea of their range and variety.

Durham Cathedral
An artists' residence scheme at the cathedral is administered by Northern Arts.

Exeter University

Teaching fellowships, one in painting, one in sculpture and one connected with Frankfurt, involving free accommodation there, free materials and studio space. Academic year of 36 weeks.

Henry Moore Foundation

Camberwell School of Art in London runs a Sculpture Fellowship worth £3,000, for an academic year with a rent-free flat and studio for ten months. Norwich School of Art offers a three-year Sculpture Fellowship, and provides a studio and helps with accommodation. Open to sculptors 'of repute'.

Oxford

There is a scheme run by the Museum of Modern Art and the university colleges for a fellowship and accommodation at a college. A similar scheme is operated by Kettle's Yard at Cambridge.

University of Wales

Runs the Greynog Arts Fellowship.

The above typify the kind of fellowships which are available in varying numbers, but there are many more which regularly crop up financed by local authorities, industry, churches and other institutions. To pick up on these, close attention to the press and art magazines is essential.

Prizes

There is an increasing number of prizes being offered in the art world. Some of these are highly prestigious and worthwhile, some are exercises in public rela-

tions, some are bestowed out of benevolence, some are relics from the past. Obviously no serious artist should be too sanguine about receiving a gift – which can vary from a supply of watercolour paints to £25,000. But it is important that you should always keep your eyes open for any prize for which you think you may qualify. Many tend to be awarded to certain groups of people bound together by professional or personal relationships, but that is a risk you will have to take, and it is not inevitable.

There is one type of prize for which you do not have to apply. It consists of those prizes given to participants in mixed open exhibitions, such as those of the Royal Academy, the Royal Society of Portrait Painters, and many local art societies, usually for categories such as 'the most promising painting in the exhibition', 'the best child portrait' or 'the best view of Kent'.

These are usually allocated by the selection committee, though sometimes it can be by the votes of visitors to the exhibition. The prizes for which you can apply – a process which involves sending your works, or transparencies of them – are many and varied. Some are not recurring, and it would be impossible to give a comprehensive list. Here, however, is a representative one. Closing dates vary, and you should always check with the appropriate source. The figures given below are for 1988, so some may now be higher.

Arnott's National Portrait Award

Bill Kelly, Arnott's, Henry Street, Dublin 1. An Irish affair, with two prizes of £1,000

and two of £500, as well as smaller prizes donated by various firms. Sending in date usually in September.

Athena Art Awards

Athena Art Awards, PO Box 4, London W1A 4YZ. Tel. 01 493 0677.

Open to any artist over the age of 18 living and working in the UK. Any work in a two-dimensional medium, not more than 30sq ft in overall dimensions, is eligible. Athena reserves the right to negotiate copyright. Eight awards of £1,000 will be made, and of these one will be selected for an award of £25,000. This usually goes to an artist of well-established reputation. Winners so far have included John Bellany, Paul Huxley and John Hoyland. There is however one prize guaranteed for an artist under the age of twenty-five, and every effort is made to ensure that one of the £1,000 prizes goes to someone working in watercolour, pastel or print. An exhibition of selected works is shown in February, the deadline for sending in is usually early in November.

Benson & Hedges Gold Awards

Wellbeck Public Relations Ltd., 2 Endell Street, Covent Garden, London WC2H 9EW. Tel. 01 836 6677.

Prizes to the value of £17,000 for photographs or illustrations on a theme given each year (e.g. 'style').

Cleveland Drawing Biennale

Department 11, PO Box 52, Middlesbrough, Cleveland.

An open drawing exhibition held every two years (there is one in 1989), with prizes and purchases up to about £7,000.

These are determined by the selection committee.

Francis Williams/W.H. Smith Illustration Competition

Dr Leo Freitas, The National Art Library, Victoria & Albert Museum, London SW7.

Originally quinquennial and founded by Francis Williams 'to encourage good illustration in books and magazines produced in the ordinary manner'. It is now supported by W.H. Smith as an annual event, with a first prize of £3,000, two second prizes of £1,000 and others of £500. Previous winners have included Paul Hogarth, Ralph Steadman and Charles Keeping, so obviously the standard is fairly high.

Humberside Print Competition

Details from your local art gallery or college of art, or Tel. 0482 25938.

Organized by the Humberside College of Higher Education, and held in Hull, usually in November, with the closing date for applications in July. It offers prizes of £700, £500 and £300, plus numerous guarantees to purchase. An exhibition of selected entries is held at the Ferens Art Gallery.

Hunting Group Art Prizes

The Exhibition Manager, Mall Galleries, 17 Carlton House Terrace, London SW1Y 5BD. Tel. 01 930 6844.

Open to artists of any nationality resident in the UK. An open-ended competition with a slightly traditionalist bias, offering a first prize of £5,000; four prizes of £2,000; and two prizes of £1,000. Prizewinners have included a fairly wide range of age

groups, though one of the prizes of £1,000 is reserved for an artist under twenty-five in the May of the relevant year. Deadline is usually in the third week of March, and an exhibition of the prizewinners and other selected works is held in the Mall Galleries in May.

John Player Portrait Award

Entry forms from the Competition Office, National Portrait Gallery, St Martin's Place, London WC2H OHE.
Tel. 01 930 1552.

For portrait painters between the ages of eighteen and forty in the January of the year of entry. You must initially submit a colour slide of your painting, which can be in oil, tempera or acrylic. The first prize is £8,000, plus a commission worth £2,000 to paint a well-known sitter for inclusion in the National Portrait Gallery's collection. The second prize is £1,000, the third £500. Approximately fifty of the entries are chosen for an exhibition subsequently held in June (a good source of potential commissions). The winners are generally comparatively little-known artists, usually in their late twenties or early thirties. The deadline for submissions is usually in March.

Laing Art Competition

Entry forms from John Laing plc,
14 Regent Street, London SW1Y 4PJ.
Tel. 01 930 7271.

John Laing plc sponsors an art competition based on British landscapes and seascapes for possible use as a company calendar. Entry is free and £2,000 is offered in prizes.

Lloyds Bank Young Printmakers Award

Application forms from the Assistant Secretary, Royal Academy of Arts, Piccadilly, London W1V ODS.

A scheme, now in its eighth year, which sponsors original prints by artists under the age of thirty. Four successful applicants will be invited to design an image for a print, and each will receive £850 as well as the cost of producing the edition.

Royal Overseas League

The Director of Art, Royal Overseas League, Park Place, St James Street, London SW1. Tel. 01 408 0214.

The League holds an annual open exhibition in August to which anyone can submit. A top prize of £2,750 is offered by the League together with additional prizes offered by private sponsors.

Smith Biennale Exhibition

The Smith Art Gallery & Museum, Dumbarton Road, Stirling FK8 2RQ. Tel.0786 71917.

Designed for artists in Scotland, with prizes of £3,000, £2,000 and £1,000, and sponsored by Scottish Amicable. Entry forms usually to be in by August, with the exhibition in September.

Tolly Cobbold Awards

Eastern Arts Association, 8-9 Bridge Street, Cambridge CB2 RUA.
Tel. 0223 67707.

Held annually with an impressive array of prizes up to £10,000, in addition to guaranteed purchases. The resulting exhibition, which takes place initially at Kettle's Yard, Cambridge, subsequently tours the UK.

Turner Prize

The Tate Gallery, Millbank, London SW1P 4RG. Tel. 01 821 1313.

Awarded annually, in conjunction with the Tate Gallery, to the person who has contributed most to British art in the previous twelve months. This may not be an artist, it could be a critic, or a gallery, but so far the prize has been awarded to artists of the calibre of Howard Hodgkin and Gilbert and George. The sum involved is £10,000. The entrants have to be nominated by someone other than themselves. Nominations have to be in by May, for a shortlist in the early summer, and the award in the winter.

Wiggins Teape Drawing Competition

Details from Mrs J Lingham, Wiggins Teape, Chartham Paper Mill, Canterbury, Kent.

Confined to architectural drawings on a set theme, e.g. 'a future for the past of the rural heritage', with the standards determined by the viability of the concept (even though it may not come from a professional architect). Total prize money £10,000, the first prize being £5,000.

These are only some of the major awards and competitions. Prize money indicated above will change, in some cases, each year, the amounts (usually) becoming larger, as one would expect. There are many others which are offered on a once only basis, and you must pay constant attention to the national press as well as to art papers and magazines.

Many awards which involve an exhibition demand an entrance fee ranging from about £2 to £9. In addition there are also a great many held on an international basis, a good proportion in the USA. You should, however, think carefully before entering for one of these. Your transport costs can be very high; you have little guarantee about the safe return of your work; and some of them seem to be run on a purely profit-making basis, the scale of the prize bearing little relation to the total of entrance fees exacted. If in doubt, consult the British Council or the International Association of Art.

Sponsorship

In the present economic and political climate, business sponsorship of the arts is the 'in' thing. On the whole, however, it is of little use to the individual artist. Its main purpose is to secure publicity and financial advantages for the participating company.

To obtain sponsorship for a prestigious exhibition – preferably of artefacts from the past – is easy enough; and any other support going is much more likely to be directed at institutions than individuals. As far as contemporary art is concerned, the most beneficial activities of companies from the point of view of artists have been those directed towards competitions and prizes, some of the best known examples being Tolly Cobbold, the Moores family of Littlewoods fame, and a few others.

Information about companies which are involved in such schemes can be obtained from the **Association of Business Sponsorship of the Arts**, 2 Chester Street,

London SW1X 7BB, Tel. 01 235 9781 – although it cannot offer help on individual cases.

However, there may be a chance of getting a smaller local firm to sponsor a specific project, especially if it has some relationship to the firm's own activities. Another possibility is persuading a commercial organization to make space available for a work of public art, e.g. a mural or a piece of sculpture.

Help for Study and Travel Abroad

If you are a 'serious' artist, that is if you have been to an art school, spend most of your time on art, have exhibited or are an art teacher, there are many bodies, some British though most foreign, which will help you study or teach or work abroad. A comprehensive list of these can be obtained from the Fine Arts Department of the British Council, 10 Spring Gardens, London SW1, in a booklet costing £3 – which of course covers subjects other than fine art.

Most countries (especially Commonwealth ones) offer grants and scholarships, and the best reference books are:
Study Abroad, UNESCO, Place de Fontenoy 75, Paris 7 (also available in this country from H.M. Stationery Office);
Grants Register, St James's Press, Percy Street, London W1.

AWARDS
Here are the main sources of awards, some of which are on an exchange basis:

Brooklyn Museum Art School. Eastern Parkway, Brooklyn, New York 11238.
Offers twenty-five scholarships annually for one year's tuition to people of all nationalities, in painting, sculpture and ceramics. Send ten slides, a curriculum vitae and two letters of recommendation.

Central Bureau for Educational Visits and Exchanges. 49 Wellington Street, London WC2. Tel. 01 486 5107.
Art bursaries for abroad; predominantly in teaching.

English Speaking Union of the Commonwealth. 37 Charles Street, London W1. Tel. 01 629 0104.
Scholarships to Commonwealth countries.

Edward Albee Foundation. 226 West 47th Street, New York 10036.
An American institution which offers a year's accommodation with free evening meals to 'twelve talented but needy artists and writers'.

France, Postgraduate Scholarships
The French Government offers a number of postgraduate scholarships in Fine Art for study in France. Apply to the Cultural Attaché, 27 Wilton Crescent, London SW1. (A number of other countries including Japan, Italy and Greece offer similar facilities. Apply to the Cultural Attachés of the relevant countries.)

German Academic Exchange Service.
DAAD, 11-15 Arlington Street, London SW1. Tel. 01 493 0614.
Fifteen scholarships to British artists up to thirty-two years old to study at German art

colleges and similar institutions. Closing date for applications in March.

Harkness Fellowships. Harkness House, 38 Upper Brook Street, London W1.
Twenty fellowships are offered annually for advanced study and travel in the USA. Art is one of the subjects which can be studied. They allow two years study and three months travel. Age limit twenty-one to thirty. Closing date in October. For details send s.a.e.

Leverhulme Trust. The Secretary, Research Awards Advisory Committee, 15-19 New Fetter Lane, London EC4. Tel. 01 248 1910.
A number of awards for study overseas, excluding Europe and the USA. Confined to those under the age of thirty. Closing date in January.

Winston Churchill Memorial Trust. 15 Queensgate, London SW7.
Each year a number of fellowships are offered for travel and study abroad. They are open to a wide range of people, and do not demand any particular academic qualifications. Each year different categories of people and subject-matter are indicated, so it is important to keep an eye open for notices about them.

Direct State Aid

It is not only specific art or 'culture' organizations which provide help. The development over the past few years of the Manpower Services Commission has opened up to a large number of people involved in the arts financial assistance on quite a considerable scale – and all available through the local Jobcentre. These schemes of course require an imaginative and explorative approach on the part of those who apply for help of one kind or another. Listed below are the main types which could be of use to artists, especially when working with others.

Enterprise Allowance
Artists, craftsmen, photographers and designers are basically occupied in running a business, and if you are starting a business you are eligible to apply for financial assistance from the Commission. With a little ingenuity you can devise a business – for example, 'portraits painted to order', 'hand-painted pictures of your home', 'sign painting', and so on. You can apply for financial help for the first year.

There is no stipulation that the business must succeed. There are, however, two important qualifications:
(a) You must have been receiving unemployment or supplementary benefit, and actively seeking employment for at least three weeks before your application.
(b) You must have at least £1,000 to invest in the business for the first year. Bank managers can be very helpful about this, and some local authorities are prepared to assist with at least part of the sum.

Having once established your art activities on what the Commission would see as a viable commercial basis, yet more help is available in the shape of:

Youth Training Schemes
Throughout history artists have had assistants, and anyone who is trying to set up

an 'art business' or impose, if you like, a commercial facade on his own artistic activities, can always make good use of the Youth Training Scheme, which allows you to take on a young person (normally sixteen or seventeen, unless disabled, when the upper age limit is extended to twenty-one), to whom you pay around £50 a week, to which the government contributes around £15. More complex and involving a greater degree of collaboration is:

The Community Enterprise Programme
Designed for a much wider age group, this covers those aged between eighteen and twenty-four who have been unemployed for at least six of the previous nine months, and those who are older than twenty-five who have been unemployed for twelve out of the last fifteen months. Basically the scheme involves working, usually in a team, on some scheme which will benefit the community. It is easy enough to incline such a scheme to an 'artistic' end: outdoor murals, statues and similar three dimensional objects, say for a playground, decorations for hospitals or similar institutions. Get into contact with other artists, or put up the idea of a project on your own.

It is important in all these Manpower Services Commission schemes to contact your local Jobcentre, and establish the viability of what you are proposing. You may find that you can get help from your regional arts association.

Social Security and Other Benefits

Social Security provides a safety net for those who, for whatever reason, do not have enough money to live on, and this can often include artists – especially those who are trying to survive by their profession alone. It is therefore important to know what you are entitled to. Self-employed persons who pay Class 2 and 4 contributions cannot claim unemployment benefit, but they are, according to their circumstances, entitled to the following (amounts given below are 1988 rates):

Child Benefits
These, currently £7.25 a week (£11.95 for single parents) are payable for all children under sixteen, or under nineteen if they are receiving full-time education. Foster-parents are not eligible, but people who have taken into their homes orphans who have lost both their parents are entitled to £8.05 a week, even if they are not the legal guardians.

Disability Allowances
For people who cannot walk, there is a disability allowance of £22.10 a week, which is non-taxable, and payable irrespective of contributions. Those who for health reasons require constant attention are entitled to £31.60 or £21.10 a week according to the degree of attention they need. There is also a basic allowance of £23.75 a week for people under pensionable age who cannot work because of physical or mental ill-health.

Family Income Supplements
These can often apply to people such as

artists, and the regulations governing them are fairly complex. these are set out in detail in DHSS leaflet FIS 1. Basically the position is this. If your income falls below a certain level (about £100 for a one-child family) you will receive half the amount by which the family income falls short of this sum, with a maximum of £26.90 for a one-child family. The self-employed (full-time work means working for someone for thirty hours or more a week) may also claim FIS, though a more likely resource is:

Supplementary Benefits

Here again the situation is a complex one, explained in DHSS leaflets SB1, SB2 and SB9. You do not have to have paid contributions to be eligible, and the basic idea is to bridge the gap between a person's needs and his resources. In calculating resources, the first £4 of part-time earnings (plus the same amount for a wife) is disregarded. This means £4 or its equivalent after deducting tax, national insurance, travelling expenses and the like.

The first £1,500 of the surrender value of an insurance policy is disregarded, so is the value of an owner-occupied house and capital under £3,000. A householder will usually have his rent and rates allowed in addition to his basic requirements.

Housing Benefit

Here again is a possible source of help for hard-pushed artists. It can take the form of a reduction in rent or rates, or a rent allowance, and is operated by the DHSS, to whose local office you should first apply. To find out if you qualify get DHSS leaflet RR1.

Pensions

There is a basic pension rate payable on reaching the age of 65 (for a man). This is currently £39.50 a week for a single person, or £63.25 for a married couple. This may be increased if you have paid in to the State Earnings Related Pension Scheme (SERPS), but this is unusual for the self-employed, and in any case SERPS is in the process of being revised. A leaflet on the subject is available from DHSS offices.

A widow's benefits are paid according to her late husband's contributions. If she is under pensionable age (sixty) and her late husband was not drawing his pension, she is entitled to widow's allowance of £55.35 a week for twenty-six weeks, provided she does not re-marry, is not living with a man (or is not imprisoned!).

YOU AND THE LAW

The areas in which an artist can come into contact with the law are manifold. These include insurance and the responsibility for the safeguarding of works of art in transit, or in the temporary possession of an individual or organization; copyright in all its complexity, and its possibilities of enhancing your income; tenancies of studios and relations with landlords.

The mere fact that art is concerned with making money means that you run the risk of getting involved in all sorts of financial and contractual problems. For example, art galleries close down or go bankrupt; and, in exceptional circumstances, some unscrupulous dealers can be very reluctant to pay what they owe. Some patrons commission a work, or 'buy' one without immediately paying, and have to be compelled to do so.

Contracts between an artist and gallery can be minefields of legal and financial problems. Then there are the unexpected pitfalls for the artist. In selling a picture, in accepting a grant or fellowship, or in various other situations, artists may, sometimes without realizing it, assume certain contractual obligations, the non-fulfilment of which can land them in hot water.

Securing the services of your solicitor can be an expensive business, so you should be aware of your legal position generally, as well as of the cheapest and most expeditious ways of coping with any problems which may arise.

Relations with a Gallery

It is clearly important that your relationship with a commercial gallery should, in both your interests, be as specific and clearly defined as possible. It is not legally necessary for there to be a written contract, although one of the legal phrases which must be remembered when dealing with a gallery is 'the customs and usage of the trade'. This, in the absence of a written contract, could mean that the gallery owner or his client could destroy the work of art, alter it or exhibit it anywhere in the world without the consent of the artist, or even without advising him of the fact.

To avoid such unforseen complications, a written contract is definitely advisable. There are two basic types of arrangements with galleries. The first is for the gallery to hold a one-off exhibition of your work, the second is for the gallery to act as your agent, taking your works of art on a sale or return basis.

A contract for an exhibition should cover the following points: the dates of the exhibition; the responsibility for private views, postage of invitations, printing, delivery and collection, and insurance; amount of commission to be exacted by the gallery, and when it will be paid; liability for loss or damage to works; whether the VAT is included in the prices asked; and who is responsible for the framing and hanging of the exhibition –

emphasizing that the artist retains the copyright of the works.

Some of these provisions also apply to a situation when a gallery accepts paintings on a sale or return basis, but in this case the arrangement should also specify other points. Obviously a list of the works left and their prices, indicating whether VAT is involved, is essential; as is the statement that the works deposited remain the property of the artist until they have been sold and paid for by the gallery, and that any or all of them are to be returned to the artist.

A specific note should be made of the fact that if any of the works are stolen, lost, destroyed or damaged in any way when in possession of the gallery, it shall inform the artist and be liable to pay the sale price less commission. It should also be emphasized that all these terms will apply if the gallery has lent or hired the works of art to a third party. A regular account of works sold and unsold should be rendered to the artist.

Relations with Clients

Unfortunately, even what seems like a simple, straightforward transaction can be beset with pitfalls. There are in the first instance certain responsibilities, admittedly of a rather ambiguous kind, incumbent upon the artist who sells a work of art. The artist, theoretically at least, is bound by the provisions of the Sale of Goods Act of 1893, which states, among other things, that goods should be of merchantable quality and reasonably fit for the purposes for which they were bought. Although the world of aesthetics is hardly an appropriate one for applying tests such as whether something is 'merchantable', the 'fitness for the purpose' phrase can impinge on the area of commissioned work, especially where portraiture is concerned.

Clients can frequently – as the case histories of Augustus John's portrait of Lord Leverhulme and Graham Sutherland's of Churchill clearly show – demonstrate that there is a lack of common ground between the way in which the client sees himself and how other people see him or her.

There are various ways of dealing with this problem, the most common one being the appointment of referees.However, no arrangement will ever persuade a disillusioned sitter that he has received value for money. Although when a commissioned work is for a site or some similar purpose, a lot of potential aggravation can be avoided by the artist supplying sketches of what he proposes to do, and securing the client's approval at an early stage.

In all cases, however, when selling a work an artist should try to make as specific a transaction as he can. Any written agreement is nearly always binding, but if none exists, the law assumes that in selling a work an artist agrees to any or all of the following: that the buyer can refuse to allow the artist ever to see it again; that he can exhibit it anywhere in the world; and that the artist must undertake, at his own expense, any restoration or similar work necessary as the result of any natural deterioration of the purchase. This can be especially problematic in relation to pieces of sculpture.

(As for future reproduction, copyright remains the property of the artist, unless otherwise assigned, except for in the case of commissioned portraits.)

To avoid such implications, which have a legal viability if no alternative contract or bill of sale exists, it is advisable that some document should exist, signed by both buyer and client, specifying that the copyright should be vested in the artist (see pp. 87-9, *Copyright*); that he or she should have access to it whenever reasonable; that the work can be borrowed by the artist for exhibition purposes, and that it will not be exhibited without the artist's consent.

Grants, Fellowships, etc.

If an artist receives a grant, fellowship or anything of that nature, he enters into a contractual relationship with the relevant organization of a different kind from that with a dealer or client. This can vary a great deal, but the terms are always specified in the documentation connected with the grant, and should be read with care and attention.

Typical of many are the Conditions of Financial Assistance issued by Greater London Arts to those seeking grants:

● The offer of a grant or guarantee against loss in the current financial year does not imply any guarantee of further or similar funds in subsequent years.

● Any alterations in the details of the application or variations in the budget must be notified immediately.

● Grants made by the Association are outside the scope of VAT, and to present any such sum in your accounts may falsely inflate your VAT turnover or bring you within the VAT range.

● The artist retains all copyright or other rights.

● The Association does not accept responsibiltiy for loss or damage to material submitted in connection with the grant, and will not accept liability for damages arising from fire or other causes (e.g. in relation to a work on a public or semi-public site).

● Recipients of grants must be willing, if requested, to submit to the Association a full report of the effects of the grant on the development of their work.

● Any publicity or printed matter consequent upon the grant (e.g. the catalogue of an exhibition which it has made possible) should acknowledge the assistance of GLA.

Getting Redress

How should you obtain redress if a gallery or client does you some financial injustice? The obvious answer is to consult a solicitor; although there is always the alternative possibility that some art organization to which you belong might take up the cudgels on your behalf. Today, however, it is comparatively easy to initiate a 'Small Claims' action in the County Court which, unlike magistrates' and Crown Courts deals with financial and similar actions between individuals. You can initiate an action yourself in the County Court under many headings, but those most likely to be relevant in the case of an artist are:

● Claims for payments of debts or money

due for goods sold or work done.

- Claims against people who have provided faulty service (e.g. in this context, framers, carriers, printers, suppliers of materials etc.).
- Disputes between landlords and tenants.
- Claims for damages concerning your person (if medical attention has been necessary a solicitor's help will be needed), or possessions.
- Claims for wilful damage to property (e.g. if one of your works is slashed or defaced and you can identify the culprit).
- Claims for wages, salary or retaining fee owing or payable in lieu of notice.

The County Court can dispose of many claims without a trial, either because the party decides not to defend the action, or because it is obvious that he or she has no defence. The County Court can deal with claims up to £1,000, though in the case of those over £1,000 there may be complications, especially if the sued party employs a solicitor. The whole process is described in an admirable booklet issued by the Lord Chancellor's Office, *Small Claims in the County Court: how to defend and sue small actions without a solicitor*, which can be found at your local library.

However, it is one thing to obtain a judgement, quite another to make it effective – especially with such possible complications as the bankruptcy laws. A judgement in your favour will include an order that the defendant shall pay the amount found due. If this order is not obeyed, responsibility for enforcing it rests with you and not the court.

The court will help you to obtain your money, provided that the debtor has the means to pay. Money due under a County Court judgement is payable to the court, which pays out monies received once a month. Judgements which have not been paid in full within a month of the entry of judgement are recorded at the Registry of County Court Judgements, 99 Redcross Way, Borough, London SE1. Tel. 01 407 1044. Anyone, on payment of a fee, can make a search of these records – a useful and much-used way of checking on people's financial standing.

How to Get Your Money

A judgement may stipulate that the sum be paid forthwith, or by weekly, monthly or other instalments. If it is not paid there are several ways you can ensure that it is – provided of course that the defendant has the money. Basically these are:

- By attachment of goods, which the court will effect through a bailiff.
- By attachment of earnings, which involves the defendant's employer deducting a regular amount from his salary and paying it to you via the court.
- Garnishee proceedings, by which the defendant's bank is ordered to pay you the money owed, or as much of it as is available from his account.
- If the debtor owns a house or land a charging order can be made against such possessions, though this can be a very complicated business.

In all these cases, however, it is possible for you to effect them without having recourse to a solicitor, and once again this is clearly set out in a pamphlet from the Lord Chancellor's Office entitled *Enforcing Money Judgements in the County Court: how to obtain payment without a solicitor.*

Copyright

Every work of art, whether it is musical, literary or visual, has two dimensions as a piece of property. The first is the individual, original work; the second is reproductions of it. We are accustomed to the vast fortunes now made by musicians of all kinds from recordings of their works, and by the generally smaller fortunes made by best-selling authors in the form of royalties paid on the sale of their books.

We are aware also that TV and radio programmes such as 'Desert Island Discs' can be copyright so that each broadcast involves a payment to the originator of the idea. But we are far less aware of what copyright of a painting or print or a piece of sculpture implies, and the extent to which it can be a source of profit.

Copyright History

As far as art is concerned, copyright has an interesting history. It was Hogarth, anxious to prevent the pirating of his prints, who first introduced and fought for the idea, succeeding in 1734 in bringing about the first Engraving Copyright Act. In 1766 it was amended to protect Hogarth's widow, extending protection to any per-

son making an engraving from the work of another, and ten years later this was extended to make it illegal to copy an engraving by somebody else.

In the nineteenth century the Act was again extended to cover new reproductive processes such as lithography, and dealers such as Ernest Gambart made fortunes out of marketing prints of well-known paintings such as *The Light of the World* and *Derby Day*, the copyright of which he bought from the artists and fought extensively in the courts to protect. Today there are agencies which take enormous pains to track down reproductions, even in quite obscure papers or magazines, of works by highly successful artists. These agencies are usually employed by their estates and demand often quite high reproduction fees.

Copyright Today

There are certain fundamental points you need to know about copyright. The original legislation which gives it validity, the Copyright Act of 1956, has been replaced in 1988 by the Copyright, Designs and Patents Bill – which, for instance, gives the County Courts the jurisdiction previously exercised by the High Court. There are certain fundamentals which an artist must understand about his rights in this matter.

Except in the case of portraits, the copyright of any work of art remains with the artist, even if he or she has been commissioned to produce the work of art in question for somebody else – although the artist can specifically sell it to a pur-

chaser. However, the employer of an artist (e.g. a Local Education Authority) in most cases owns the copyright of any work of art he or she may produce at work, just as it 'owns' the works which students produce at an art school.

According to paragraph 4 of the new Bill, 'artistic work' means:

● A graphic work, photograph or sculpture, irrespective of artistic quality.
● A work of architecture, being a building or model for a building.
● A work of artistic craftsmanship.

It goes on to specify that: 'graphic work' includes any painting, drawing, diagram, map, chart or plan, as well as any engraving, etching, lithograph, woodcut print or similar work; and that 'sculpture' includes a cast or model made for the purposes of sculpture. It does not, however – perhaps fortunately – digress on the meaning of the phrase 'work of artistic craftsmanship'.

Copyright in an artistic work expires at the end of fifty years from the end of the calendar year in which its creator dies. But with photographs, copyright – which belongs to the owner of the photograph rather than the taker – expires at the end of the period of fifty years from the year in which the photograph was published, and the same rule applies to computer-generated works. It is also worth noting that the new Bill specifically states that infringement of copyright covers 'exhibition in public'.

Infringement of Copyright

Copyright does not protect ideas as such, or even styles. It applies only to a finished work of art, and the sketches connected with its creation. Nor does it cover work produced 'after' others. To infringe copyright they have to be direct imitations. In the case of infringement of copyright (e.g. if one of your works is reproduced without your permission in a paper, advertisement, greeting card, etc.) the editor, manager, printer and publisher are all liable.

Britain has now accepted the Berne Copyright Convention, originally drawn up in 1886 and revised in 1971, according to which the creator of a work of art can 'object to any modification which is prejudicial to his honour or reputation'. This is obviously of importance in cases where the person or body which has commissioned a work wishes to alter it to conform with their own ideas.

The copyright law in general forbids affixing another person's name on a work which is not his or hers; to publish or sell an altered artistic work or reproduction of such a work as if it was unaltered; or to publish, sell or distribute reproductions of a work of art as reproductions by the artist knowing this is not the case.

Anybody whose copyright is infringed can obtain an injunction against a repeat of the offence; claim damages for infringement based on the evidence of loss suffered by the artist; or upon a claim for conversion which relates to the value of the offending work. An alternative remedy is to seek an account of profits which is the

standard by which damages are assessed. The plaintiff is entitled to these even when the defendant's ignorance of the existence of copyright in the work is proved or admitted.

Common sense should govern all actions for the infringement of copyright, the important point being that the artist should know that it exists, and that copyright is a 'property' which he or she can sell in addition to the actual work of art. It would perhaps be injudicious to charge for reproduction of one of your works which might bring you welcome publicity, although if you don't agree with the accompanying comment you might well decide to claim your copyright fee!

A most important organization for dealing with copyright matters is the **Design and Artists' Copyright Society**, St Mary's Clergy House, 2 Whitechurch Lane, London E1 1ED, which deals with the collection of copyright fees. Helpful too is the **Artists' League of Great Britain**, Bankside Gallery, Hopton Street, London SE1.

MAKING TAX TOLERABLE

It is a well-known fact that there is more than one way to skin a cat, and this gruesome proverb can certainly be applied to making money as an artist. Making money is one thing – holding on to it quite another. But one of the ways in which it can be saved, as countless people in the upper income brackets know, is at the expense of the taxman. For the best part of a century, taxation has been a battlefield, where citizens are pitted against the officials of the Inland Revenue. The rules of warfare which exist in this context are, let's face it, rather uneven; although it is possible to turn the situation to your advantage. To do this it is essential that you gain at least a good working knowledge of the subject.

If you are an ordinary employed person, your tax is deducted from your wages or salary at source. You have precious few opportunities for doing anything about it, and any allowances you can claim are negligible. This position is technically known as paying tax under Schedule E. Though it is almost impossible to avoid it, it is possible for a practising artist to lessen its impact by qualifying for paying at least part of the tax due on his or her total income under a more flexible tax bracket, called Schedule D.

Schedule D

To qualify for this tax category, in which you can claim tax relief under a quite considerable range of headings, you must persuade the taxman that you are carrying on your artistic activities 'on a commercial basis with a view to the realization of profits', and these profits need not be substantial, nor need they be your sole source of income.

The most important thing is to avoid giving the impression that you are painting, or whatever, as a hobby – a notion which, if you are trying for the first time to get assessed under Schedule D, the inspector will enthusiastically promote, for the simple reason that if you make a loss it can be carried forward and set against any profits which might accrue in the future. If, however, you are working as a professional on a commercial basis, losses can be off-set against any other income you might have earned, so possibly resulting in a tax repayment.

Some artists are entirely self-employed, and in this case all their income is assessed under Schedule D, but probably the majority of the readers of this book also earn money as employees, either full or part-time, and so would have to pay tax under two different schemes. In the past, it was possible under certain circumstances to claim the money earned in a job, especially if it was part-time, as part of

your total income as a professional artist; and some art colleges phrased their contracts in such a way as to make this claim seem viable.

More recently, however, the Inland Revenue has been taking a far less accommodating stance, and it is virtually imposible to get any income which you may obtain, for example as a part-time art teacher, absorbed into the Schedule D system.

It is also possible for tax purposes to 'spread' amounts of money received over two years for a work which has taken twelve months or more to complete, and over three years for one which has taken two years to complete, so preventing you being put into a higher income bracket in one particular year because of receiving a large sum for a work in that year. The same principle applies to the sale of prints or other forms of duplicated art works, the receipts for which may well come in over a lengthy period.

Unemployed and Self-Employed

If you are unemployed, benefit is theoretically taxable, but of course this hardly ever happens because the benefit is covered by your personal allowance – the annually adjusted amount of income which everybody can earn before tax is deducted. If, on the other hand, you have been employed during part of the year, your personal allowance will be set against what you get in twelve-monthly instalments, and at the end of the year you will receive a repayment from the tax office.

What about being both unemployed and an artist who is beginning to make money out of art? In the first place there is a daily earnings restriction, and if you are to receive benefit you must also be prepared to take a job of another kind if the DHSS finds a 'suitable' one for you.

If you are self-employed, tax is usually payable in two equal instalments on 1 January and 1 July, although if you take what the Inspector sees as an unacceptably long time to pay it, interest is payable to the tax authorities at the rate of 8.25 per cent.

An important point to be remembered by those who have a mixed-schedule tax situation, is that you should ensure that your personal allowance is set against the income you receive from your employer, for this means that you get the benefit of it each month; whereas if it is set against your professional income, you will have to claim a refund at the end of the year, and it can be a long wait before you get it.

If you feel unable to cope with tax problems you can always, if your income allows, employ an accountant (the fees you pay him are deductible from tax). The main advantage of such a move is that the Inspector will treat his version of your returns with a respect he may not always give the ones you supply yourself.

Allowable Expenses

It is absolutely vital that you should keep a record of all your expenses, including outgoings like bus fares, exhibition catalogues, postage, and magazines (connected with art or related to your work).

Retain as many receipts as you can – the Inspector may ask to see them. On the whole, people such as artists tend to underestimate their expenses, or forget to include items which could contribute to the total.

The general rule is that expenses, which can be claimed against tax, must have been incurred in the pursuit of one's profession or business. It does not have to be 'necessary', but 'wholly and exclusively' for the purposes of your professional activities. This covers both your general career as an artist, and specific instances such as the costs of holding an exhibition.

However, the position is by no means a simple one. There are on the one hand clear-cut types of expenditure – for materials, for instance, which are allowable; while there are other expenses which would not be considered essential to the pursuit of your career.

But between these there is a large debatable area where constant argument is staged between Inspectors and taxpayers, and in which final decisions are sometimes taken in the courts. Say, for instance, that you are painting a landscape which is some considerable distance from your place of residence, and therefore you cannot return home for lunch. That seems to fall within the category of expenses that one would expect to be classed as allowable. Not so, however. The courts decided in the test case of Caillebotte v. Quinn (appropriately named for artistic purposes, but not involving the Impressionist of the same name) that, as the claimant eats to live as well as to work, the claim was not justified.

The same kind of argument can be applied to a whole range of expenses that have duality of purpose. Clothing, for instance, can only be claimed if it is of a specifically technical kind.

There is, however, a very important point to notice. No law or regulation can cater for every debatable claim which a taxpayer can make. A very great deal depends on the Inspector; and, to put it rather naively, you should always try to remain on the right side of him. For a start, return your forms as promptly as you can, and put your viewpoint clearly and persuasively.

Acceptable Expenditure

There are many areas of expenditure where duality of purpose exists, but in which the Inspector will allot a fixed proportion as tax-deductible. Included in these are the following:

● A reasonable amount can be claimed for 'use of home', including lighting, heating, rates, insurance, cleaning and maintenance. This sum will be arrived at by discussion with the Inspector, and is applicable whether you rent your home or own it. If you own it, there is a possible snag about how you argue your claim. If you say that part of the house is reserved solely for your work, it may well lose its Capital Gains Tax exemption as an only or main place of residence. The same principle of a proportionate allowance applies to telephone expenses.
● Travel is also a mixed area. Certain

types of travel can be directly attributed to your professional activities – going to another town to see a client or gallery owner, taking your pictures in a taxi to the gallery, visiting an exhibition which is important to your career as an artist. But there are certain areas where a potential duality exists. If, for instance, you go to Italy, ostensibly to paint the Rialto Bridge or the Tuscan Hills, you are also having a holiday.

In cases like this it is best to present on your tax returns the total expenditure involved, and suggest a proportion as being a tax-deductible allowance. You are of course entitled to a much more generous allowance if, for example, you are attending a course or participating in a conference or congress.

- Self-employed people cannot take advantage of the legislation which affords tax relief according to the size and cost of a car. It is, however, possible to claim a proportion – arrived at in discussion with the Inspector – of the running expenses of a car, which can vary according to the location of one's home and the nature of one's art.
- There is of course a wide range of expenses which (though the Inspector may query the actual sums involved) are allowable; hence the necessity of keeping as much documentation as you can. Allowable expenses include: materials of all kinds necessary for your artistic activities (this can include not only art materials as such, but stationery and other materials which are auxiliary to your activities); all ex-

penses connected with secretarial or other help, though you must be wary of employing your spouse, as he or she will have to show the putative fees on his or her tax return; and insurance, commission, agents' fees, accountancy charges, and expenses connected with publicity including photographing your works, printing catalogues, having colour separations made, postage, answering machines and the like.

- It is generally accepted that though you may not claim for an initial purchase of something like a typewriter, word-processor or camera, you may claim for a replacement. Activities ancillary to your professional ones may be claimed, and this is an area which allows scope for a certain amount of ingenuity and imagination. These could include repairs to studio and equipment, replacement of working clothes, postage, and even bank charges.

Art journals and other professional magazines are obviously included, but so too could be the quality daily and weekly papers, as a means of keeping abreast of those aspects of contemporary life which are essential to your artistic career. You cannot claim for most books, but you can claim for reference books, and, where relevant, their annual renewal; plus subscriptions to art groups and art societies, as well as entrance fees and catalogue costs to exhibitions which you have to visit in pursuit of your artistic career
- An exhibition is absorbed into the normal annual returns of the year in which it occurs, but of course it presents cer-

tain features of its own. These can best be exemplified by the figures of a survey of some thirty-six artists who held exhibitions in public galleries, published in *Artists' Newsletter* in October 1986. The average allowable expenses involved in an exhibition were as follows:

Preparation of work for exhibition (framing etc.) £183

Packaging and crating of works for dispatch to gallery £13

Transportation of work to gallery £12

Insurance of work in transit £2

Photography for publicity/catalogue £12

Production of catalogue and publicity £86

Installation of work £4

Travel to dismantle exhibition and take away £8

Other costs incurred £25

Total expenses £405

The total income received from the exhibition, including sales which occurred after it, came to £454, so tax is payable only on £49. It might be added as a footnote, that as a result of the exhibitions, eight artists were offered exhibitions at other galleries, three received coverage in the national media, and twenty-four received publicity in local media.

Grants, Prizes, etc.

This again is a battleground, though an uneasy truce exists between the Arts Council and other involved bodies, and the Commissioners of the Inland Revenue. There are various anomalies, but the general position is this: following a recent decision of the courts, prizes as such are tax free. So too are various bursaries and grants given, not for producing specific works of art, but for allowing an artist to take time off from other money-making activities to develop his professional skills.

On the other hand, commissions from the Arts Council and Regional Arts Associations for works for public sites and similar purposes, and grants for completing specific projects or mounting exhibitions, as well as for publishing art books, are as a general rule subject to tax. As with so many other things in this rather twilight area, discuss it with your Inspector and see how far he will let you go.

Relief on Pensions

Any self-employed person, and this applies to artists perhaps even more than others, should think seriously about the subject of pensions. And from the tax point of view there is every incentive to do so. When you contribute to a pension scheme, tax relief may be obtained each year for an amount up to 17½ per cent of earnings. If on the other hand you contribute Class 4 National Insurance contributions, which are additional to the ordinary contribution payable by a self-employed person, you do not get the relief on the same scale – but you can claim for one half of these contributions. It must be remembered, of course, that pensions are regarded as income.

Capital Expenditure and Allowances

When you spend money on an expensive piece of equipment, such as a printing press, electronic equipment or an extensive photographic system, the sums expended qualify for a 25 per cent tax allowance in the year of purchase, and 25 per cent of the balance in each succeeding year until the sum is covered. It is of course important to make such claims in years when your income exceeds your allowances, otherwise the relief would be wasted. It is, in almost all cases, better to buy such equipment rather than to lease it.

VAT

Income tax is a problem-free impost in comparison with VAT, which involves, among other things, visits from officials to examine your business records and activities. They will want to know how you record goods you receive and supply, and how you deal with cash going in and coming out. They are able to visit your premises at any reasonable time. Heavy financial penalties can be imposed for failure to apply for registration, failure to keep or produce VAT records, and the unauthorized issue of tax invoices.

There is, however, one initial consolation. You only have to register for VAT if your annual income exceeds a certain amount (£21,300 a year in 1988); though even here there is a snag. There is a quarterly limit (currently £7,250) which, if exceeded, renders you obliged to register, and the penalties for failing to do so are draconian. VAT officers do not accept innocence, ignorance, or financial incompetence as an excuse for not complying with the law.

Basically, the idea of VAT is that if you are registered you increase the price of anything you sell by 15 per cent, and then claim for the VAT on the things you buy. A reckoning is made, and you pay the VAT people the appropriate VAT on what you've sold, or they pay you according to how the sum works out. It is therefore possible, especially if you have heavy expenditure, to be in an advantageous position as far as the tax is concerned. It is of course essential to keep the most detailed and accurate accounts.

A tax invoice for VAT must contain the following particulars: an identifying number, your name and address and VAT registration number; the time of supply; your client's name and address; the type of supply (e.g. sale or rental); the quantity of goods or extent of the services; the charge made, excluding VAT, the rate of any cash discount offered and the total VAT payable. If you are paid in cash you must, if asked, clearly show on the invoice that cash has been received, and the date of receipt.

VAT covers a wide variety of activities. For VAT purposes, self-employed persons carrying on 'any trade, vocation or profession' earn an income, which in these terms means any continuing activity which involves providing something to others for money. The activity must have a degree of frequency and scale, and be continued over a period of time. Isolated transactions are not normally subject to VAT. However (and this is an important point

for artists to remember) even if your activities have some or all of the above characteristics, they are not classed as a 'business' if they are essentially a recreation or hobby.

It needs an expert to explain all the intricacies of VAT, so a visit to the inspectors is advisable. Alternatively, you can obtain a wealth of information written in comparatively understandable prose from leaflets and pamphlets available at your local VAT office. The most relevant ones are: *The VAT Guide, The Ins and Outs of VAT, Filling in your VAT Return, Should I Register for VAT* and *Keeping Records and Accounts*; plus the informative *Value Added Tax* and *Secondhand Works of Art, Antiques and Collectors' Pieces*.

VAT and Artists

There are various problems specifically relating to artists, especially in their dealings with galleries. If you are not registered for VAT and sell a work to a gallery there is no complication, and the question of VAT doesn't arise. If, however, the artist is registered for VAT he will add 15 per cent to the price he charges the gallery. When the gallery sells the painting, it will not charge the buyer for VAT on any commission it hands over to the artist. If therefore the sale price of the picture is £600, and the rate of commission is 20 per cent, the artist will receive £600 less £120 commission less £18 VAT, viz £462. If, however, both the gallery and the artist are registered, the sale price will be £600 plus £90 VAT, viz £690. Commission will

be £120 plus £18 VAT, so he will actually get £462, which comes to the same thing in the long run.

National Insurance Contributions

National Insurance contributions are not a tax, but they have exactly the same effect: they diminish your expendable income. If you are in full-time employment, there is no problem – they are deducted from your salary, and that's that. If, however, like many artists, you are self-employed, problems can and do arise. To evade them is, in the long run, disastrous, and can preclude you from a pension. Everybody in Great Britain is legally bound to pay National Insurance contributions, and if you are 'a person in business on his own account' you will pay one or other of the following contributions:

Class Two

Flat contributions by the self-employed. You can, however, obtain a certificate of exemption if you are an OAP, under sixteen, a married woman, in receipt of sickness, disability or invalid care allowances; or – and this is where the rub comes – either not ordinarily self-employed, or 'a person with small earnings'.

The first of these categories means, in practice, that you are included in it if you have another job, and your earnings from your creative activities do not exceed a certain amount. 'Small earnings' is a sum which is set at the beginning of each financial year, which tends to rise by about five per cent each year.

If your earnings fall below that sum you can claim exemption. It should be noted, however, that a person who can claim exemption from Class 2 contributions can continue to do so if he or she wants to maintain entitlement to social security benefits. Payment can be made either by direct debit, or by stamps purchaseable from Post Offices.

Class Three

This covers voluntary contributions in order to qualify for a limited range of social security benefits for those whose previous contributions had not reached that amount. They can be paid by the employed and the self-employed as well as the unemployed.

Class Four

Self-employed people are liable to pay Class 4 contributions in addition to Class 2. These are deducted at the rate of 30 per cent on profits made over and above £4,950 per annum, but which do not exceed £15,780, after deducting capital allowances and losses, but before deducting personal tax allowances. One half of the Class 4 contributions which you make is deductible in arriving at a figure of your total income. This deduction, which in practice is given automatically, refers to total income and not to the profits assessable under Schedule D. The contribution due under Class 4 is calculated separately for husband and wife, though the liability is that of the former, unless they have chosen to be taxed individually. Individuals who are not resident in the United Kingdom for tax purposes are exempt, as, of course, are retired persons and juniors.

Full information about National Insurance Contributions is available from DHSS leaflets.

SUPPLEMENTARY WAYS OF EARNING

Being an artist is a full-time occupation only for the extremely successful, and there are very few today – even among the successful – who will not need either to supplement the income they get from selling their works, or find an alternative employment. Most will have to push their careers as artists as a predominant subsidiary occupation, hoping to succeed as professionals, or, if not, becoming 'Sunday painters'. Obviously, if you have been trained as an artist it makes sense to try to get some occupation, full or part time, which relates to your skill or expertise.

Such openings can take many forms, not all of them immediately apparent. It is a well known fact that many successful pop musicians have art college backgrounds, as well as successful politicians, soldiers and businessmen of all kinds, who are not only artists but often make a considerable subsidiary income from their activities.

But this book is not primarily addressed to artists of this kind. For those whose main concern in life is their art, there exists a whole spectrum of opportunities, many of which cannot be reduced to an easy formula. Basically it is very much a question of your own imaginativeness and ingenuity.

There are of course obvious outlets such as teaching, but there are many other less obvious ones. Included in these are activities in areas which used to be called 'commercial art', and are now vaguely known as 'design'. These are not in fact quite so rigidly circumscribed as one may think. You do not need to have done graphic design at college to become an illustrator. You can get involved in theatre or set design without having done a relevant course in that subject; you can get involved in commercial forms of craft, in wood for instance, even though you studied sculpture and not 3D. Painting, drawing and sculpture form the lingua franca of all kinds of creative and potentially remunerative activities. It is up to you to exploit them.

Teaching

Teaching is, and probably always will be, a major source of income for artists of almost all levels of achievement. The reasons are obvious. You are engaged in a profession to which you are attracted; you can continue to develop your own style; even if you are a full timer you have more generous holidays than most people do; and the pay, if not princely, is, at worst, adequate. But before examining teaching

as a source of income for artists in detail, a few generalizations should be noted.

Many people go straight into teaching from art school, and usually spend the rest of their lives in it. To them, teaching is a full-time profession, and indeed it is not all that easy to start teaching at a secondary school level. There are others who go into it later in life, often after having had two or three moderately successful exhibitions; but who, faced with the realization that their financial needs are not going to be catered for at that time by selling their works of art, decide to take a part-time job at an art college, or the fine art department of a polytechnic, or wherever.

This can often lead to a full-time appointment, which, as we shall see, can be extremely attractive. Many succesful artists have kept on their teaching activities until very late in their careers – the President of the Royal Academy, for instance, is the Principal of an art college. But teaching art does present certain hazards, some of a subtle kind.

Economic pressure is a great incentive to furthering your career as an artist, and to have that incentive removed can lead to a weakening of one's creative drive. Teaching art to children can be emotionally rewarding, but it can also lead to a degree of something approaching complacency. In the field of higher education, the same combination of pluses and minuses operates.

Higher Education

Life in an art school can be very stimulating, bringing artists into contact with new ideas, both from students and from other members of staff. But it can be claustrophobic, and some people find that the constant need to formulate one's ideas about art, and to teach them to others, can diminish their spontaneity and vitality.

Full-time teaching in higher education presents another hazard. Gone are the days when this kind of teaching was a relaxed, almost bohemian way of life. Today a full-time lecturer, once he or she has passed the early stages of his career, has to be an administrator, politician, social worker, accountant, and much else besides. In certain circumstances the lecturer can spend an extremely large portion of his or her working life attending meetings, academic boards, examination boards, faculty boards, boards of studies, staff meetings, and whatever else is required.

Before encountering these hazards, however, one has to get a job in the first place; and achieving a full or part time job in the art teaching world is often no easy matter. Education is a shrinking industry because of a variety of factors, but as far as fine art is concerned, this has been compounded by political considerations.

Because it does not seem to contribute directly to the national wealth, perhaps because in the 60s and 70s art students were seen to be especially radical or perhaps because as a whole the British are not over-enamoured of art, art schools and faculties of fine art are either being closed down or emasculated.

It might, however, be worthwhile at this point noting one thing. Most art colleges

teach more than fine art. They cover graphics, textiles, fashion, three dimensional design, and varying combinations of these, often under different and usually more pretentious names.

On the whole, these faculties are not being treated in quite so draconian a fashion as fine art, but most of them thinking, quite rightly, that fine art provides the basic grammar and inspirational impetus of most design, employ one or more fine artists on their staff, if only as token figures.

Secondary Education

Getting a teaching job in secondary schools is hedged round with more provisos than similar posts in higher education. There are two alternative qualifications. The first is a degree in art and design at an art college, plus a one-year postgraduate art teacher-training course.

Postgraduate Courses

The following institutions offer postgraduate courses in art education. For admission apply to **The Graduate Teacher Training Registry**, 3c Crawford Place, London W1H 2BN. Apply after the October preceding the year in which you wish to start and give six choices.

Birmingham
School of Art Education, Birmingham Polytechnic, Margaret Street, Birmingham B3 3BX.

Bristol
School of Art Education, Faculty of Art & Design, Bristol Polytechnic, 35 Berkeley Square, Bristol BS8 1JA.

Cardiff
Department of Art Education, South Glamorgan Institute of Higher Education, Cyncoed Centre, Cardiff CF2 6XD.

Leeds
Leeds Polytechnic, School of Education, Beckett Park, Headingley, Leeds LS6 3QS.

Leicester
Leicester Polytechnic, Centre for Post-Graduate Studies in Education, Scraptoft Campus, Leicester LE7 9SU.

Liverpool
Department of Education, Art & Design, Liverpool Polytechnic, Gambier Terrace, Liverpool 1 7BL.

London
Goldsmith's College, New Cross, London SE14 6NW.
Middlesex Polytechnic Art Teacher's Course, Trent Park, Cockfosters, Barnet, Herts EN4 OPT.
University of London Institute of Education, 20 Bedford Way, London WC1H OAL.

Manchester
Centre for Art & Design Education, Manchester Polytechnic, 1 Wilmslow Road, Didsbury, Manchester M20 8RR.

Northern Ireland
Department of Education, Ulster Polytechnic, Jordanstown, Newton Abbey, Co. Antrim.

Reading

School of Education, Reading University, London Road, Reading RG1 5AQ.

The class of degree you get can influence your salary for the rest of your teaching career. If you achieve a first or upper second you will receive marginally more. Schools teach a variety of art and design subjects, according to their size and complexity. A village school obviously cannot offer the same range of 'creative' activities as an urban comprehensive, but the whole spectrum can include: painting and drawing, sculpture, printmaking, graphics (including computer-aided), ceramics, wood, metalwork, textiles, photography, video and film-making.

Getting a Job

Teaching jobs are predominantly full-time (part-time teaching is often on a temporary basis) and nearly all are advertised in the *Times Educational Supplement* or the *Guardian* on a Tuesday, though it is always worth keeping an eye on the local press and art magazines, especially for appointments in schools outside the state system, which can often be more indulgent towards the art staff.

The scale of salaries can be consulted in what used to be called the *Report of the Burnham Committee* which can be found in most public libraries. It will reveal that to be the head of the art department in a large school can be quite remunerative, and that there are special allowances for teaching in certain deprived areas.

You don't have to possess a teaching diploma to get into higher art education. Theoretically at least, you don't even need to have a degree, but it is essential to have what goes with an art school training – contacts. Ideally, having done a postgraduate course at the Royal College of Art, the Slade or the Royal Academy Schools is an enormous help, because all these institutions are, as it were, unofficial employment agencies in the world of art and design. Contacts are essential, and although most jobs are advertised, quite a lot are not, and end up being filled by word of mouth.

The circumstances in colleges of art vary a good deal, but on the whole they are fairly relaxed. The academic year lasts for thirty-six weeks, and full-timers come in usually four – or in some cases three – days a week, the 'free' time to be devoted, theoretically, to research and general self-improvement. Sabbatical leave to undertake some painting project, or prepare for an exhibition, can sometimes be obtained. You can also take parties of students abroad during the vacation.

Full-time teachers in higher art education receive an automatic annual salary increase (in addition of course to any negotiated national salary increment), and they automatically rise in status until they have reached the top of the Senior Lecturer scale appropriate to the institution at which they teach. Additional advantages are that your employer pays a hefty chunk of your national insurance contributions.

There is a contributory pension scheme into which you pay, although, once again, your employer pays a larger portion.

There is also security of tenure. If you work in or near London there is an additional increment to your salary.

If the institution at which you teach is part of a university (e.g. the Slade School of Art, which is part of University College, London, or the faculties of Fine Art at Reading and Newcastle) the pay scale is that of universities, which is both higher and more elastic.

Part-Time Teaching

For the majority of artists who need a source of income more reliable than that provided by the sale of their works alone, part-time teaching in a college of art is the ideal solution. The hours you can obtain per week vary according to circumstances, but are usually between four and twelve. Obviously you do not get paid during the sixteen weeks of holidays which occur in the academic year, nor do you have security of tenure. Indeed it is part-time teachers who have been worst hit by the current wave of cutbacks which have hit the academic world.

When the Association of Teachers in Technical Institutes (the trade union which covers teachers in this area) secures an annual increase for its members, administrators, faced with shrinking revenues, have to find the extra money by dispensing with part-time staff. However, if you have spent more than a certain time a week over a period doing part-time teaching, you have a right to apply to be taken on the permanent staff at a salary proportionate to the part-time work you do. That is to say, you are paid a propor-

tion of a lecturer's salary, the payment being spread over the whole year. You have as secure a tenure as anybody else, you are entitled to redundancy pay, you are entitled to a contributory pension scheme, national insurance is looked after, and you can probably maintain your Schedule D status.

Recreational and Evening Classes

Art teaching is, however, not confined to schools and colleges of art. It is carried on in a variety of other ways, and in other contexts, such as artist-in-residence schemes, and schools and museums projects, often funded by local authorities. Most towns and cities have a variety of recreational and evening institutes where art classes are carried on. These are run by the local education authorities, whom you should contact if you wish to teach on them.

A number of museums and art galleries have educational schemes, sometimes involving actual painting, but more frequently falling into the category of art appreciation, a subject to which any painter or sculptor can, given the gift of the gab, apply him or herself with some degree of persuasiveness. The mere fact that anybody who has graduated in fine art over the past twenty years has had to devote a third of course time to art history can be made into a recommendation for this kind of work. Here again very much depends on your own initiative. Although major public art galleries have highly organized and tightly scheduled programmes of lectures and educational activities,

there are some which would probably welcome suggestions along these lines, especially if they were linked to some particular travelling exhibition.

If you find it easy to communicate verbally, the lecture field can provide a reasonably rewarding source of additional income. In the first place, many schools and colleges of art invite people to give occasional lectures, especially if, say, they are currently holding an exhibition in the area. There is also a plethora of clubs, institutions and organizations of a social, religious or political nature which welcome talks or discussions on subjects connected with art, though even at best they are only likely to pay a modest fee. There are of course agencies which arrange lectures on a commission basis, and there are official panels of lecturers, but at this level a high degree of professionalism is demanded, and it implies a virtually full-time dedication to lecturing.

Tuition

There are still some people who want private tuition in art, though they are not as numerous as they used to be, for there are so many alternative (and cheaper) ways of securing the same kind of instruction. However, you should always bear them in mind, and if you have the inclination, try some small advertisements in the personal columns of The Times or the Daily Telegraph, in magazines such as The Lady or Country Life, and even in the columns of your local paper.

You can of course start your own art school, beginning modestly with one or two people, and then, one hopes, expanding. With an increasing number of older people in the population, this is very much a growth industry at the moment, as a perusal of the advertisements in The Artist will show. Clearly you have to have suitable accommodation, and the more picturesque it is, the more likely you are to succeed.

But there are ways around this, especially if you get involved in the running of a summer school. If, for instance, you have been going for some time in the summer to a particular place abroad to paint, there is no reason why you should not arrange a summer school there, hiring accommodation such as a school, boarding your students in neighbouring farms and hotels, securing the support of the local tourist authorities, and advertising the delights you are offering in magazines.

It is perhaps the kind of enterprise best undertaken in collaboration with others (such as contemporaries from art school days) to share the quite considerable organizational, teaching and social obligations such an enterprise involves. But there can be no doubt that quite a large number of artists have found this an agreeable and remunerative way of turning their creative talents to good account.

Art Therapy

Closely allied to art teaching in the educational field is the ever-expanding role of art in a therapeutic context. There has been an increasing awareness over the past quarter of a century that painting and other forms of creative activity can play a

quite considerable part in helping people with physical, psychological and social problems, and there is a demand for artists to operate in this area. Artists who go into art therapy can find work in hospitals, schools for the physically and mentally subnormal, and day centres for those similarly afflicted.

The basic premise of art therapy is that by painting, drawing, and sculpting, those who participate can achieve increased physical dexterity, and externalize or sublimate their problems, so giving the medical staff a vital clue to their condition – as well as finding an occupation which can alleviate the frustrations of an institutionalized life.

Obviously what is needed in this context are not only artistic and communications skills, but some awareness of the nature of psychopathology, and of the attitudes to adopt to the physically and mentally afflicted. This may come from practice, however, and if for whatever reason you feel yourself drawn to this kind of work (which is predominantly part time), a preliminary diploma in art therapy is almost essential. The courses are usually two years, part time, or one year for students who already hold a teaching diploma. These are the major institutions which offer such courses:

Birmingham Polytechnic, School of Art Education;
Goldsmith's College, University of London;
St Alban's College of Art & Design, Hertfordshire.

The pay scales in this area are not generous – closer to those of nursing than art teaching proper, but once having acquired the experience and/or a diploma, it is of course possible to have more than one job, and most people who have gone in for this kind of activity find it very rewarding.

Similar work, though naturally of a slightly different nature, can also be obtained in prisons, where art has come to play a significant role. For this kind of work contact the Prisons' Department of the Home Office. An invaluable umbrella organization for all these activities is SHAPE, 9 Fitzroy Square, London W1 6AE, which acts as an agency for those interested in, among other things, the social and therapeutic applications of art.

Employment in the Arts

One of the most remarkable phenomena of the post-war years in the world of culture has been the growth of 'cultural bureaucracy' – of an ever-increasing number of people involved in the administration of museums and public art galleries, and the mushrooming agencies which are concerned with running these bodies – agencies such as the Arts Council, the British Council, and Regional Arts Associations, all of which deal with the patronage of art, the organization of exhibitions and similar activities in the museum and art gallery world.

There is an increasing amount of professionalism now demanded, and a degree in art history is essential for top jobs in the museum and gallery world. Until the 1930s all the directors of the National

Gallery, the Victoria & Albert Museum and the Tate were painters. Some of the greatest administrators of the post-war world – Lillian Somerville and John Hulton at the British Council, Gabriel White at the Arts Council – were basically artists. The point is, that administrative and managerial skills of the kind required in this context can be fairly easily acquired. What is really needed is a sensitivity to the product.

A degree in art can offer opportunities for employment in a whole variety of art-related jobs. (The *Guardian* on Mondays is a useful source for advertisements for such jobs.) Unlike teaching, however, such employment is part time, but it can be reasonably well paid: the Arts Council, for instance, spends around two and a half million pounds a year on salaries.

The qualities you have to possess or acquire are obvious, and are in fact not dissimilar to those needed in business or the civil service. The Arts Council provides free leaflets and publicity on careers and courses in art administration, and works in collaboration with two institutions to provide slightly differing qualifications in the field. These are:

The Polytechnic of Central London, 309 Regent Street, London W1, which offers a one-year postgraduate course;

City University Centre for the Arts, Northampton Square, London EC1, which has a postgraduate Diploma in Art Administration, and a one-year practical training scheme.

Stirling University also runs a one-year training scheme in theatre and arts administration.

Museums and Galleries

As well as jobs in art administration, there are countless opportunities in commercial art galleries, though on the whole they are not very well paid. They involve many differing kinds of work – selling, hanging exhibitions, making the tea and so on. Secretarial skills of some kind are almost always essential, and there is nothing remotely approaching security of tenure. But it can of course be a lot of fun.

The world of museums and public art galleries opens up another whole range of potential employment, and as we have said above, many of its leading lights are, or have been, artists. Nor are the jobs available confined to what most people think of them as being – i.e. curators and the like. Public art institutions of all sizes employ staff who deal with exhibition design and mounting, conservation, public relations, graphic design, picture framing and so on.

It is no longer easy to get into this world without some professional qualification, which comes after taking a first degree. For full details of these contact: **The Museums' Association**, 34 Bloomsbury Way, London WC1, or consult *The Libraries, Museums and Art Galleries Year Book* (James Clarke & Co. Ltd.).

Leeds University, in collaboration with Leeds City Art Gallery, runs a course in decorative arts, and Leicester University offers a one or two year certificate in museum studies. Manchester University has a one-year post-graduate course in museum studies, while Hastings College and Humberside College of Higher Educa-

tion give vocational courses in the same area.

Art History Courses

Obviously, for any job in the museums and art galleries' world it helps if you have more detailed knowledge of art history than that afforded by the ordinary fine art or design degree. There are several ways of achieving this. Of all art history institutions in Britain, the most prestigious and the most influential is the **Courtauld Institute of Art**, 20 Portman Square, London W1, which offers a variety of courses at various levels, including postgraduate courses.

There are many other institutions which offer postgraduate degrees in art history, including Birmingham Polytechnic, Brighton Polytechnic, and the Universities of Bristol, Cambridge, Kent, Essex, Leeds, Leicester, Manchester, East Anglia (Norwich), Nottingham, Oxford, Reading, Sussex, Warwick, Aberdeen, Edinburgh, Glasgow, St Andrews, and the University College of Wales. For those who cannot afford a full-time course there is an admirable part-time option at Birkbeck College at the University of London, where you can acquire an MPhil or a PhD; and the Open University also has degrees in art history.

Picture Restoring and Conservation

There is currently great demand for picture restorers. In part this is due to the growth of the public art gallery and museum world (which of course includes organizations such as the National Trust, as well as individual owners of stately homes), which is deeply concerned with problems of conservation and restoration. Both these activities involve a wide range of skills, and demand varying and sometimes exacting qualifications.

Conservation has become a highly technical profession, which in most cases demands some scientific interests, and at least an 'A' level in Chemistry. You must realize, too, that conservation has to do with a lot of things other than paintings. The Victoria and Albert Museum for example offers studentships which last four years, pay a basic salary, and are usually specifically aimed at filling vacancies in one or other of the museum's departments – textiles, ceramics, etc.

With picture restoration however, painting skills are highly desirable. Very many of the paintings on the Old Master/ Victorian circuit are bought at auctions, usually in a sorry, if not a deplorable state, and before they are offered to a discerning public they have to be cleaned, touched-up (which can sometimes involve practically repainting whole areas), and sometimes rebuilt. Canvases have to be restretched, reinforced or even darned. It is obvious that activities such as these need the skills and experience of a painter, and though it is of course possible to make picture restoration alone a full-time and indeed highly profitable job, it is also one which can be carried on in tandem with activities as a practising artist.

To become a restorer in a public art gallery is more demanding in the qualifications it requires, and once again,

as in the conservation area, would undoubtedly be a full-time occupation. In the more relaxed area of commercial and private work – for individuals are frequently having accidents with their works of art, or feel a need to have them brightened up – there are endless opportunities for part-time work. Once you have got yourself known, you will be surprised how many odd jobs will come your way, and a little advertising in a local paper would do no harm.

Like all traditional professions, conservation and restoration was, and still can be, based on apprenticeship, and if you can persuade some known picture restorer to let you work with him or her it would not only be a good introduction to the craft, but would provide you with useful contacts. Remember too that it is not only oil paintings which come within the orbit of picture restoration; it can also include works on paper, drawings, prints and other media.

Whether or not you manage to attach yourself to someone already versed in these skills, it is always a good thing to have a preliminary qualification, and there are several institutions which offer courses in restoration and conservation. Grants for these can sometimes be obtained from local authorities and other sources, even from the Job Training Scheme. The institutions are:

Camberwell School of Arts and Crafts, Peckham Road, London SE5. Courses in paper, print and drawing restoration of one year duration.
Courtauld Institute of Art, Portman Square, London W1. A three-year course in painting conservation.
Gateshead Technical College, Durham Road, Gateshead. A two-year postgraduate course in painting conservation and restoration.
Hamilton Kerr Institute, Whittlesford, Cambridge CB2 4NE. Three-year course in painting restoration.

There are also courses in other fields of restoration, including sculpture, and in the latter area most cathedrals have an ongoing restoration programme which takes on assistants, but there is obviously less demand in this medium than in those which involve painting and drawing.

Illustration

Never before have created images proliferated as much as they do today. We are swamped with them: in books, periodicals, newspapers, packaging, advertising, billboards, TV – wherever we look there are pictures or graphic signs and symbols. And behind each there is an artist or photographer. What used to be called 'commercial art' is a boom industry. It offers to those trained in fine art, graphics, or to a lesser extent sculpture, full-time employment, or a supplementary form of income to enable them to maintain their status as 'real' artists.

Full-time employment as an illustrator can be found in the fields of advertising, design consultancy, the whole range of daily, weekly and monthly journalism, publishing of all kinds, printing, television and film, marketing and elsewhere. On the

whole it would be true to say that those who find full-time employment in this area have often done a graphics course at their art college, for it can demand skills in typography, technical drawing and photography.

On the other hand, some of the most famous and successful art directors of the past few decades have been trained as painters, and many well-known artists have started off as full-time employees in agencies.

Conditions vary enormously, from a cosy post with a small publisher to being one of a legion in a multi-national company, faced with conflicting pressures from account executives, clients, art directors and copywriters.

There are all kinds of organizations which may take artists directly from art school, usually as trainees on a less than modest salary, and the early career pattern of those who make this decision is often to start with a large firm to get the appropriate training, then perhaps move on to a more responsible job in a smaller one.

Possible Employers

Advertising agencies are large employers of creative talent, and the aspirant must be prepared to undertake a wide range of jobs, in varying degrees of collaboration with others, but all basically involving the making of imagery.

Next come design consultancies and studios, organizations varying greatly in size, but all dedicated to selling the art world to commercial or private clients.

This can involve anything from designing the interiors of a huge office complex, including furniture, fittings, decorations, murals, prints and stationery, down to providing drawings for the local paper or pictures to illustrate a special offer in some local shop.

One of the great advantages of this whole area of potential employment – and this is true whether you want it full or part time – is that there is a wealth of information available. Compulsory reading for anyone wishing to get into this world is the weekly *Campaign*, 22 Lancaster Gate, London W2, which covers the whole media world; and the monthly *Design*, Design Council, 28 Haymarket, London SW1, which among other things features a regular register of designers' services.

Perhaps most important of all is the **Chartered Society of Designers**, 29 Bedford Square, London WC1, which is the professional body for all designers, and numbers among its 9,000 members a considerable number of graphic artists. It offers an employment agency service to members looking for full-time, part-time and freelance work, and initiates contacts with potential clients. It also offers advice on legal, financial and professional problems. **The Association of Illustrators**, 1 Colville Place, London W1, provides a good deal of help on a more limited, but also more specialised scale, including *Survival Kit*, an invaluable compendium of information, especially for the freelance and part-time illustrator.

Graphic Design

It is in part-time work that graphic art has most to offer those who see their real activity as being artists. If you commit yourself fully to the commercial world, the risk is of course that you end up forsaking your ambitions to achieve success in the art world proper – although naturally there are many artists of real distinction who illustrate books and commercial literature.

Being an occasional or freelance illustrator helps financially and avoids the storms and stresses of full-time employment in what can be a fiercely competitive and often insecure business environment.

There are two main approaches, not mutually exclusive, which can depend on circumstances. The first one is to seize any ad hoc occasion to send a drawing, a cartoon, or a sketch to anyone you think might publish it, especially to newspapers and magazines. You may get an idea for a topical joke, there may be some controversy about a building of which you have a drawing, or could make one for the purpose. Constant alertness to what is going on can provide opportunities for getting occasional works published, and it is vital to remember that every work, however slight, which actually appears in print enhances your opportunity of getting more work accepted.

Humour

The whole field of humour is, on the whole, unexploited by artists. The style can vary according to your own gifts. The drawing itself does not have to be funny or 'caricaturist' in the style of Scarfe, Searle or Steadman; more important is the topical or social relevance, though this is not always essential.

There is indeed a lively demand for work of this kind, exemplified at its most prestigious level in magazines such as *Punch*, 23-7 Tudor Street, London EC4, and *Private Eye*, 6 Carlisle Street, London W1, but also in provincial newspapers and other outlets. Don't forget to approach with ideas any journal or magazine published by any body to which you may belong. It is of course essential to enclose a stamped addressed envelope with anything you send to a paper or journal.

It is by reading newspapers and magazines that you get some idea of their style, and the kind of illustrations they might accept, whether serious or humorous; but there are two invaluable reference books. The first, which gives advice about the kind of work editors are looking for, is the reasonably priced *Writers' and Artists' Year Book* (A. & C. Black, £5.95); and the second is *Willing's Press Guide* (IPC Business Press), which gives the titles and addresses of all British, and some foreign, publications. Both are annuals.

Greetings Cards and Stationery

There is a considerable demand for designs for greeting cards and stationery, such as gift tags, wrapping paper, invitation cards and so on. A visit to a few greetings cards shops will reveal the main styles and approaches.

Although there is a constant demand for 'pretty' pictures, of landscapes, children, and historical themes, over the past few decades there has been a growing demand for greetings cards. Greeting card manufacturers are always on the lookout for bright ideas. The humour does not have to be very subtle. Before sending material, try and find out the house style of the publisher to whom you are sending it. Always enclose adequate return postage. There is a **Greeting Card and Calendar Association**, 6 Wimpole Street, London W1. (Tel. 01 637 7692), and the following are some of the leading firms:

Artists' Cards, 411 Fulham Palace Road, London SW6. Tel. 01 736 9318.
Athena International, PO Box 13, Bishops Stortford, Herts CM23 5PQ. Tel. 0279 58531.
De Montfort Cards Ltd., 37-41 Bedford Row, London WC1R 4JH. Tel. 01 430 0251
Fine Art Graphics, Dawson Lane, Dudley Hill, Bradford BD4 6HW. Tel. 0274 689514.
Gordon Fraser Gallery., Fitzroy Road, London NW1. Tel. 01 722 0077.
Royle Publications Ltd., Royle House, Wenlock Road, London N1 7ST. Tel. 01 253 7654.
Valentines of Dundee Ltd., PO Box 74, Kinnoul Road, Dundee DN1 9NQ. Tel. 0382 814711.
Wilson Brothers Greeting Cards Ltd., Church Bridge Works, Church, Lancs. Tel. 0254 390813.
W.N. Sharpe Ltd., Bingley Road, Bradford BD9 6SD. Tel. 0274 42244.

Prints for the Domestic Market

In addition to firms such as the above, there are a number which publish prints for framing in a domestic context – the most famous of this type being the purple girl, which broke all records in popularity. Some of the firms which specialize in this kind of work are:

Felix Rosenstiel's Widow and Son Ltd., 34-5 Markham Street, London SW3 3NR. Tel. 01 352 3551.
The Medici Society, 34-42 Pentonville Road, London N1 9HG. Tel. 01 837 7099.
Solomon and Whitehead (Guild Prints), Lynn Lane, Shenstone, Staffs WS14 0DX.

Sometimes companies which deal in the production of prints will buy the copyright, and if you are a beginner in this area, there is no harm in the idea. If, however, you have become firmly established, and there is a likelihood of your work becoming popular, it is clearly better to negotiate a royalty contract, according to the terms of which you will get a percentage of the value of each copy sold – usually about 10 per cent.

Presentation

The first requisite for obtaining work in the area of illustration is to get together a portfolio of your work. Ideally this should consist of work which you have had published, but until you have reached that stage it should consist of samples of your drawings and other graphic work assembled to show both your skill and versatility. It should contain works in different media

– pen, pencil, watercolour, crayon, pastel, etchings, lithographs, whatever you do best.

It should also deal with as many different types of subject matter as you can manage without distorting your real style. On the whole, the themes should be fairly wide. There should not be more than about twenty sheets in the folio, and great attention should be paid to presentation.

Your drawings etc. should be mounted on paper, which can be tinted or coloured. Do not use a petroleum based rubber adhesive, as each sheet should be covered in cellophane or some other transparent material. You can buy, from most good stationers, specially designed album-type folios, with plastic envelopes on a ring binder system. It is sometimes a good idea to caption each entry. If it has been published state where and when; if it has not give a descriptive title and the medium. If you don't want to caption each page, incorporate a list of contents. When you do have work published, try and get hold of off-prints of it, and always keep photocopies of everything you send out.

Publishing

Of all the outlets which appeal to artists intent on making illustration a sideline, one of the most attractive is books and publishing, predominantly text illustration or book jackets. The procedure is basically quite simple. You phone or write to make an appointment, then take your portfolio to the art editor of the company, who will probably tell you that they are going to keep your name on their register of artists. Then, if and when the occasion arises, they will give you a briefing and ask you to produce a sample treatment. If this is approved you're home and dry.

Most publishers produce illustrated books of one kind or another, though there has been a notable decline in the number of drawn or painted book jackets produced, and a greater reliance on pure graphics, typography or photography. To compensate in part for this latter decline, however, record companies and music publishers occasionally commission artists to design or help design record sleeves and sheet music.

If you are really intent on making an assault on the publishing world, it is a good thing to devote several hours in your public library to inspecting the productions of different publishers. Find out which are frequent users of illustrations, and try to discover which might be most receptive to your own style.

Above all else don't forget the children's department. Illustrated books for children are always in demand, and it's even worthwhile taking some well-known text, which hasn't been republished recently, and providing a couple of illustrations for it.

The following publishers are especially interested in books for children:

W.H. Allen, 44 Hill Street, London W1X 8LB. Tel. 01 493 6777.
Sparrow and Beaver, Brookmount House, 62-5 Chandos Place, London WC2N 4NW. Tel. 01 240 3411.
B.T.Batsford Ltd., 4 Fitzhardinge Street, London W1H OAH. Tel. 01 486 8484.

A. & C. Black, 35 Bedford Row, London WC1.

Blackie & Son Ltd., Bishopbriggs, Glasgow G64 2NZ. Tel. 041 772 2311.

The Bodley Head, 32 Bedford Square, London WC1. Tel. 01 631 4434.

Jonathan Cape, 32 Bedford Square London WC1. Tel. 01 636 3344.

Century Hutchinson, 62 Chandos Place, London WC2N 4NW. Tel. 01 240 3411.

Chatto & Windus, 30 Bedford Square, London WC1B 3RP. Tel. 01 631 4434.

Collins, 8 Grafton Street, London W1X 3LA. Tel. 01 493 7070.

J.M.Dent, 33 Welbeck Street, London W1M 8LX. Tel.01 486 7233.

Faber and Faber, 3 Queen Square, London WC1N 3AU. Tel.01 278 3817.

Gallery Childrens' Books, 27-9 Macklin Street, London WC2B 5XL. Tel. 01 837 6767.

Mary Glasgow Publications Ltd., 131-3 Holland Park Avenue, London W11 4UT. Tel. 01 603 4688.

Hamish Hamilton Ltd., 27 Wright's Lane, London W8 5TZ. Tel. 01 938 3388.

William Heinemann Ltd., 10 Upper Grosvenor Street, London W1X 9PA.

Hodder & Stoughton's Children's Books, Mill Road, Dunton Green, Sevenoaks, Kent. Tel. 0732 450111.

Hutchinson's Childrens Books, 62-5 Chandos Place, London WC2N 4NW. Tel. 01 240 3411.

Kingfisher Books, 24-30 Great Titchfield Street, London W1P 7AD. Tel. 01 631 0878.

Ladybird Books, Beeches Road, Loughborough, Leicestershire LE11 2NQ. Tel. 0509 268021.

Longman Group Ltd., 5 Bentinck Street, London W1M 5RN. Tel. 01 935 0121.

Macmillan Childrens Books, 4 Little Essex Street, London WC2R 3LF. Tel. 01 836 6633.

Methuen's Childrens Books, 11 New Fetter Lane, London EC4P 4EE. Tel. 01 583 9855.

Pan Books Ltd., Cavaye Place, London SW10 9PG. Tel. 01 373 6070.

Souvenir Press, 43 Great Russell Street, London WC1B 3PA. Tel. 01 580 9307.

Viking Kestrel (Penguin), Bath Road, Harmondsworth, Middlesex UB7 ODA. Tel. 01 759 1984.

Artists' Agencies

There are many agencies which specialize in selling illustrations and other forms of visual art to publishers, advertising agencies, magazines, newspapers, and other outlets on behalf of artists. They are naturally not over-anxious to promote absolute beginners, but once you have achieved a foothold in the world of illustration you can, if your style is in harmony with the requirements of the agency's contacts, vastly increase your chances of getting work published.

Some of the leading agencies are:

Allied Art Services, 15 Heddon Street, London W1R 7LF. Tel. 01 437 5788.

Associated Freelance Artists Ltd.,19 Russell Street, London WC2B 5HP. Tel. 01 836 2507. Has strong interest in illustrations for childrens' books of both the educational and entertainment variety.

David Lewis Management, World's End

Studios, 134 Lotts Road, London SW10 ORJ. Tel. 01 351 4333. Work for publishers, magazines.

R.P. Gossop Ltd, 4 Denmark Street, London WC2H 8LP. Tel. 01 836 1058. Illustrations and ornaments for books, diagrams, maps, publicity and book jackets.

Ian Fleming Associates, 1 Wedgwood Mews, London W1V 5LW. Tel. 01 734 8701. Work for illustration of books and advertising.

John Martin & Artists Ltd., 5 Wardour Street, London W1V 3HE. Tel. 01 734 9000. Interested in a wide range of graphic material, with a special interest in educational books for children and encyclopedias with a visual slant.

N.E. Middleton Ltd., 44 Great Russell Street, London WC1B 3PA. Tel. 01 580 0999. Wide range of interests in publishing and advertising.

Maggie Mundy, 216 King Street, London W6 ORA. Tel. 01 741 5862. All aspects of illustration. Figurative work only.

Oxford Illustrators Ltd., Aristotle Lane, Oxford OX2 6TR. Tel. 0865 512331. Specialists in scientific, technical, diagramatic illustrations, working for publishers.

Russell & Russell Associates, 461 Gorton Road, Reddish, Stockport, Cheshire SK5 6LR. Any type of art work considered for everything from posters to greeting cards.

Temple Rogers Artists Agency, Room 29, Russell Chambers, The Piazza, Covent Garden, London WC2. Tel. 01 405 8295. Illustrations for children's recreational and educational books, picture strips and periodicals. Realistic style essential.

Young Artists, 2 Greenland Place, London NW1 OAP. Tel. 01 267 9661.

Art for Offices, Riverside Gallery, Metropolitan Wharf, Wapping Wall, London E1.

Artists General Benevolent Association, Burlington House, Piccadilly, London W1.

Artists' Union, 9 Poland Street, London W1.

Art Libraries Society, Brighton Polytechnic, Brighton.

Arts Club, 40 Dover Street, London W1.

Arts Council in Eire, 70 Merrion Square, Dublin.

Artspace Federation, 6 & 8 Rosebery Avenue, London EC1.

Artworkers Guild, 6 Queen Square, London WC1.

Aspects, Business Arts, 3-5 Whitefield Street, London W1.

Association of Artists and Designers in Wales, 111 Plymouth Road, Penarth, South Glamorgan.

Association of Community Artists, 38a Dalton Lane, Hackney, London E8.

Association of Illustrators, 1 Colville Street, London W1.

Association of Self-Employed Persons, 279 Church Road, London SE19.

British-American Arts Association, 49 Wellington Street, London WC2.

British Copyright Council, 29-33 Berners Street, London W1.

British Crafts Centre, 43 Earlham Street, London WC2.

British Institution Fund, Royal Academy, London W1.

British Water-Colour Society, Castle Gallery, Ilkley, West Yorks.

Business Art Galleries, Royal Academy, Piccadilly, London W1.

Camden Arts Trust, Arkwright Road, London NW3.

Canadian High Commission, Cultural Division, Trafalgar Square, London SW1.

Cartoonists Club of Great Britain, 11 Simons Lane, Colchester, Essex.

Central Bureau for Educational Visits and Exchanges, Seymour House, Seymour Mews, London W1.

Central Office of Information, Hercules Road, London SE1.

Chartered Society of Designers, 29 Bedford Square, London WC1.

Chelsea Arts Club, Old Church Street, London SW3.

Chelsea Art Society, Chenil Art Galleries, King's Road, London SW3.

Christies Contemporary Art, 8 Dover Street, London W1.

Commonwealth Institute, Kensington High Street, London W8.

Contemporary Art Society, 20 John Islip Street, London SW1.

Council for National Academic Awards, 344 Gray's Inn Road, London WC1.

Courtauld Institute of Art, Portman Square, London W1.

Crafts Council, 12 Waterloo Place, London SW1.

Design and Artists' Copyright Society, St Mary's Clergy House, 2 Whitechurch Lane,

Lane, London E1.
English Speaking Union, 37 Charles Street, London W1.
Federation of British Artists, 17 Carlton House Terrace, London SW1.
Fine Art Trade Guild, 192 Ebury Street, London SW1.
Institute of Contemporary Arts, The Mall, London SW1.
International Association of Art, c/o Valentine Ellis Accountants, Charterhouse, London EC1.
National Art Collections Fund, 20 John Islip Street, London SW1.
National Society for Art Education, Champness Hall, Drake Street, Rochdale, Yorkshire.
Railway Artists Guild, 45 Dickins Road, Warwick.
Royal Hibernian Academy, 15 Ely Place, Dublin.
Royal Institute of British Architects (RIBA), 66 Portland Place, London W1.
Royal Scottish Academy, Princes Street, Edinburgh.
Royal Society of Arts, 6-8 John Adams Street, London WC2.
Royal Society of British Sculptors, 108

Old Brompton Road, London SW7.
Royal Society of Painters in Water-Colour, Bankside Galleries, 48 Hopton Street, London SE1.
Royal Ulster Academy of Painting, Sculpture & Architecture, 10 Colson Park, Lisburn, County Antrim.
Royal West of England Academy, Queen's Road, Clifton, Bristol.
St Ives Society of Artists, Old Mariner's Church, Norway Square, St Ives, Cornwall.
Scottish Artists Benevolent Association, Netherlea, Old Mill Lane, Edinburgh.
Social Arts Trust, 20 Exchange Buildings, Newcastle-upon-Tyne.
Society of Industrial Artists and Designers, 12 Carlton House Terrace, London SW1.
Society of Graphic Artists, 9 Newburgh Street, London W1.
Society of Architectural and Industrial Illustrators, PO Box 22, Stroud, Gloucestershire.
Sotheby Parke Bernet Art Courses, 34 New Bond Street, London W1.
Workers Educational Association, Temple House, 9 Upper Berkeley Street, London W1.

The following books are useful for both practical information and a general overview of the art scene. See also p.50, where the various Art Magazines are listed.

The ABC of Copyright. UNESCO. Available from HM Stationery Office shops.
Art Diary. Annual published in Milan but available from Art Guide, 28 Colville Road, London W11. An international guide giving names of galleries, critics etc., in 38 countries.
Art Galleries and Exhibition Spaces in Wales, by Nick Pearson. Welsh Arts Council, Museum Place, Cardiff.
The Art of Survival, some ideas on selling, by A. Parkin. £2 from author at 47 Oenhill Road, Kemsing, Kent.
The Artist's Directory, a handbook to the contemporary British art world, by Heather Waddell & Richard Layzell. Art Guide Publications. 1986. £6.95.
Artists' Copyright Handbook, by Henry Lydiate. Design and Artists Copyright, 2 Whitechapel Lane, London E1.
The Arts and the World of Business, by Charlotte Georgi. Methuen. £4.90.
Arts Council Publications. There are many of these, some of which are relevant to practising artists. They include Annual Reports, and a bi-monthly bulletin, 'Directory of Arts Centres, Guide to Awards and Schemes'. Lists of these are available from the Publications Department, Arts Council, 105 Piccadilly, London W1.
Arts Review Yearbook. Arts Review, 16 St James's Gardens, London W11. £9.
Caution: A Guide to Safe Practice in the Arts and Crafts, by Tim Challis & Gary Roberts. Sunderland Polytechnic, Ryhope Road, Sunderland.
CNNA Handbook of Art and Design Courses in England and Wales. Association of Art Institutions, Imperial Chambers, 24 Widemarsh Street, Hereford.
Code of Professional Conduct. Chartered Society of Designers. 29 Bedford Square, London WC1. 65p.
Directory of Exhibition Spaces, by Neil Hanson & Susan Jones. Artic Publications. 1983. £5.95.
Economic Situation of Visual Artists, Calouste Gulbenkian Foundation. 1979. Available in libraries only.
Institute of Chartered Accountants, Digests Nos. 188 & 208 (dealing with Social Security). Moorgate Place, London EC2.
Journal of Art and Design Education. National Society for Art Education, 7a High Street, Corsham, Wiltshire.
London Art & Artists' Guide. Art Guide Publications, 28 Colville Road, London W11. £3.95.
Making Ways, the visual artist's guide to survival, by David Butler. Artic Producers

Publishing Co. 1987. £7.95.
Organizing Your Own Exhibition, by Debbie Duffin and Jonathan Harvey. Acme Publications, 15 Robinson Road, Bethnal Green, London E2. 1987. £3.
The Phaidon Companion to Art & Artists in the British Isles, by Michael Jacobs and Malcolm Warner. Phaidon Press. £12.95.
Prints and Print-Making, by Anthony Griffiths. British Museum Publications. £5.95.
Some Notes for Young Artists on Galleries and Marketing, by Philip Wright. Scottish Arts Council, 19 Charlotte Square, Edinburgh.
Who's Who in Art. Trade Press. £10.
Writers' and Artists' Yearbook. A. & C. Black. £5.95.

INDEX

A

alternative exhibition spaces 41-2
approaching a gallery 24, 25-6
Art and Design Admissions Registry 16, 19
art centres 32-3
art colleges 96, 102-3
 – entry requirements 16
art education 15-20
art groups and organizations 38-9, 43-5, 71-3, 117
art history 109
art publications 47-50, 94, 110-11, 115
art therapy 106-7
artists' agencies 115-16
artists-in-residence 73
artists' materials 11
artists, types of 9, 10, 91
arts administration 107-8
Arts Associations 61-71
Arts Council 30, 32, 57, 58, 95, 107-8
 – of Great Britain 58-9
 – of Northern Ireland 59-60
 – Scottish Arts Council 60-1
 – Welsh Arts Council 61
'Artweeks' 42
Athena Art Awards 75
awards 57, 74-7, 78

B

British Council 78, 107-8
Buckinghamshire Arts Association 61

C

capital expenditure and allowances 96
catalogue, exhibition 28
clients, relations with 12-13, 84-5
commission, gallery 25, 83, 84, 97
company sponsorship 77-8
conservation 109-10
Contemporary Art Society 30
contracts 27, 83, 84, 113
copyright 83, 84, 85, 87-9
County Court 85
Courtauld Institute of Art 109
critics 47-50, 58

D

dealers 24-7, 47, 83, 97
debts, payment of 85-6
design, employment in 111-12
Development Corporations 33, 34

E

earnings 11, 91-8
Eastern Arts 64
East Midlands Arts 63-4
employment 10, 11, 91, 101-2, 104-16
Enterprise Allowance 79
exhibiting 11, 12, 23-45, 47, 53, 77, 83, 93,
 95
expenses, allowable 92-5

F

Foundation courses 15
funding 57-81

G

galleries
 – commercial 11, 24, 25-30, 47, 83, 97,
 108, 109
 – municipal 29-32, 105, 108, 109
 – provincial 11, 23-4, 28-30
 – public 30
grants 19, 57, 58, 71, 85, 95, 110
graphic design 101, 110-12
Greater London Arts 67-8, 85
greetings cards 112-13

H

humorous art 112
Hunting Group Art Prizes 75-6

I

illustration 110-11
illustrations (for publicity) 24, 26, 27, 28,
 48, 57
invitation cards 53, 83

J

John Player Portrait Awards 76

L

Laing Art Competition 76
law, and artists 83-9, 91
libraries 31, 34-5
Lincolnshire and Humberside Arts 65
loss liability 83, 84, 85

M

Manpower Services Commission 79-81
museums, employment in 108

N

National Insurance 97-108
newspapers 49-50
Northern Arts 68-9
North West Arts 68

O

open exhibitions 40-1

P

pensions relief 95
picture restoring 109
polytechnics 15, 16
postgraduate study 17-19, 103-4
 – entry requirements 19
presentation of work 24, 25-6, 48, 113-14
press releases 49
pricing 12, 24, 26
prints 113

private art schools 20
private tuition 106
private views 53, 54
prizes 57, 74-7, 95
publications 47-50, 94, 110-11, 115
publicity 24, 27, 28, 35, 41, 47-54, 113-14
public relations 24, 26, 47, 74
publishing 114-15

R

radio and television 50-2
Regional Arts Associations 11, 38, 58-70, 95
restaurants, exhibiting in 42
Royal Academy 40, 74
Royal College of Art 18

S

Sale of Goods Act 84
sales outlets 11, 42-3
Slade School of Fine Art 18
Social Security 80-1, 92
South East Arts 69-70
South West Arts 70-1
sponsorship 77-8
State aid 79-81
stationery 112-13
stores, exhibiting in 42
studio accommodation 21
studio, open 42
study abroad 78
supplementary benefits 79-81

T

tastes 10, 24
tax 26, 83, 84, 91-8
teaching 102-6
 – in higher education 102
 – part-time 105-6
 – evening classes 105
Tolly Cobbold Awards 76
Turner Prize 77

U

unemployment 79-81, 92
university art courses 17
University Central Council on Admissions
 17
universities, exhibiting in 35-7

V

Value Added Tax 26, 83, 84, 96-7

W

Wiggins Teape Drawing Competition 77

Y

Youth Training Schemes 79-80